EUROPEAN CAMERA OF THE YEAR '93–'94

D1136476

In North America

the Canon EOS 5 is known as the

Canon A2E/A2

All text, illustrations and data apply to cameras with either name

HOVE FOTO BOOKS **Steve Bavister**

In North America
the Canon EOS 5 is known as the
Canon A2E/A2

All text, illustrations and data apply to cameras with either name
Canon EOS 5
First English Edition September 1993
Reprinted 1994
Reprinted January 1996
Typeset by Jersey Photographic Museum
Printed by
The Guernsey Press Co. Ltd, Commercial Printing Division,
Guernsey, Channel Islands

British Library Cataloguing-in-Publication Data
A catalogue record for this book is available from the
British Library

ISBN 1-874031-05-3

All rights reserved. No part of this book may be reproduced in any form,
or translated, without permission in writing from Hove Foto Books.

Hove Foto Books Limited
Jersey Photographic Museum
Hotel de France, St Saviour's Road
St Helier, Jersey, Channel Islands JE2 7LA
Tel: (01534) 614700 Fax: (01534) 887342

© 1993 Hove Foto Books

® Canon is the registered trademark of Canon Inc.

Worldwide Distribution:
Newpro (UK) Ltd
Old Sawmills Road
Faringdon, Oxon,
SN7 7DS, England

This publication is not sponsored in any way by Canon Inc. Information, data and
procedures in this book are correct to the best of the author's and publisher's knowledge.
Because use of this information is beyond the author's and publisher's control, all liability is
expressly disclaimed. Specifications, model numbers and operating procedures may be
changed by the manufacturer at any time and may, therefore, not always agree with the
content of this book.

The author would like to thank Canon Inc. for their assistance and permission
for the use of illustrations and drawings.

Canon

EOS

5•*A2E*
A2

Contents

Foreword

EUROPEAN CAMERA OF THE YEAR '93–'94

Pick up the Canon EOS 5/A2/E for the first time and you feel like Captain James T. Kirk standing on the bridge of the Starship Enterprise. All those knobs, switches, dials and buttons, all those flashing lights and LCD displays.

You feel excited by all the power and all the possibilities it brings, but also a little intimidated by all the technology.

What does this switch do? Or that button? Does it blast the Klingons? Make the coffee? Or calibrate the Eye-control system? Who knows?

What you really need is someone on hand to help you, someone like Mr. Spock, someone who can clearly and calmly talk you step-by-step through the various features of the camera, what they do and how to make the most of them.

That's what this book is for. To help you realise the full potential of the incredible picture-taking machine they call the Canon EOS5/A2/E.

Read it carefully and you'll quickly find yourself in full command of the camera, and ready to boldly go where no photographer has ever been before.

Enjoy your photography,

Steve Bavister,
August 1993.

Note for Readers: The Canon EOS5 is known as that in all markets except North America, where it is called the EOS A2E, the two cameras differing only in minor points, relating to flash and viewfinder display, which are highlighted in the text. There is also a North American version called the EOS A2, which lacks the eye-control feature, but has an adjustable diopter correction eyepiece, which the EOS5 and A2E do not. According to Bob Shell, author of the excellent Canon EOS Book, also published by Hove, if the EOS A2 sells well it may be offered in other parts of the world as the EOS 7. For convenience in this book, the camera will be referred to as the Canon EOS5/A2/E. Where differences exist, they are described in the text.

Acknowledgments

I would like to thank everyone who assisted in any way with this book, but in particular my wife Jane without whose patience and understanding it would never have been possible.

EUROPEAN CAMERA OF THE YEAR '93–'94

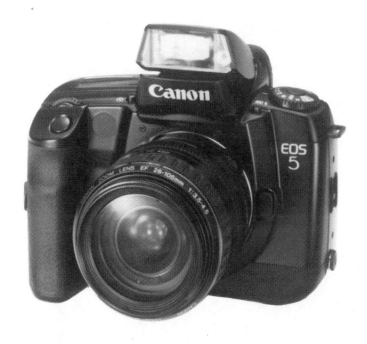

THE CANON EOS5/A2/E

Introduction

The Canon EOS system (pronounced ee-oss) was launched in 1987 with the introduction of the ground-breaking Canon EOS 600 (US 630), and right from the start it was clear that this was no ordinary range of cameras, but something very special indeed. The EOS 600/630 quickly caught the imagination of the camera-buying public, and soon began to challenge the dominance of the then market-leading Minolta Dynax/Maxxum range.

A steady succession of EOSes followed, each bringing new ideas and radical thinking to the design of SLR cameras: input dials, bar-code programming, custom functions, silent technology, USM lenses. Nor were these innovations just to be found in the top-end models: everything from the popular EOS 1000 (US Rebel) to the professional EOS 1 brought something new to the party.

Then in October 1992, at the Photokina show in Cologne, Germany, Canon unveiled the 15th camera in the EOS system, the EOS5/A2/E, to an amazed and delighted photographic world.

A buzz went round the show. Everyone wanted to see and try it. Even the writers from photo magazines, who thought they'd seen it all, done it all, were talking excitedly about the Canon EOS5/A2/E, and queueing up patiently to get their hands on it.

Some were sceptical about the camera's revolutionary Eye-Control focusing system – until they tried it! – whereupon the scepticism gave way to admiration for what Canon had achieved

The consensus was that this was another milestone in camera design, on a par with the introduction of autofocus itself. Naturally much of the interest focused (sorry!) on

the Eye-Control System, but there's actually a lot more to the camera than just that. It also boasts an incredible array of highly-advanced and mouth-watering features, including:

- a top shutter speed of 1/8000 sec
- a flash synchronisation speed of 1/200 sec
- eight exposure modes
- a choice of three metering patterns
- three different focusing options
- near-silent film wind up to 5 frames-per-second
- a built-in TTL autozoom flashgun with red-eye reduction
- a range of 16 user-programmable Custom Functions
- Auto Exposure-Bracketing
- Multiple-Exposures

It's a fantastic specification, and owners of the EOS5/A2/E can pride themselves in possessing one of the most sophisticated cameras ever made – and one with enough features to keep even the most demanding photographer happy for a picture-taking lifetime.

But you'll know already, assuming you've had the pleasure and privilege of using an EOS5/A2/E, that in this case "sophisticated" doesn't mean "complicated". Despite the fact that it's packed to the gills with state-of-the art technology, the camera remains incredibly easy to use.

And that is Canon's enormous success with the EOS5/A2/E: it's a camera to suit all levels of skills, from novice to veteran photographer.

Set it up one way, in the automatic Green Rectangle Mode, and you have in your hands a versatile and easy-to-use point & shoot SLR – with perfect pictures virtually guaranteed. You'll find it capable of doing everything for you but frame the shot and press the shutter release –

and it's a fair bet that the Canon Research & Development boys are working on that one right now!

But set it up another way, taking advantage of the many Creative Exposure Modes, autofocus, drive and metering options, and personally-set custom functions, and you have at your disposal a professional-specification SLR that's capable of doing whatever you ask of it.

I have a simple test of whether a camera's good or bad. A good camera is one which makes it easy for photographers to take the pictures they want. A bad camera is one which hinders them.

On that basis, the Canon EOS5/A2/E is one of the very best. It's a camera I very much enjoy using, and I'm confident you will too.

All photographs throughout this manual have been taken by the author.

Editor's Note: Rather than duplicate the contents of the Canon EOS5/A2/E Instruction Booklet, this manual shows you, in a clear and easily understood way, how to obtain that little extra from your photography, and at the same time explains all the functions on the award winning European and Japanese 'Camera of the Year' for 1993/94 - The Canon EOS5/A2/E.

1. CAMERA (front view, with flash up):

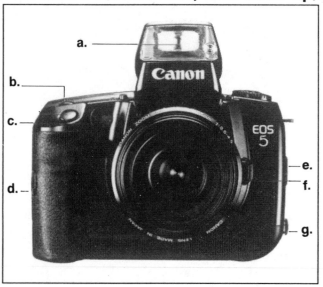

a. Pop up built in flash

b. Input dial

c. Self-timer operation light

d. Grip attachment release

e. P.C. Terminal socket

f. Lens release button

g. Back cover latch

CANON EOS5/A2/E

An introduction to the operating controls (in alphabetical order).

AE-Lock/Custom Function button

Best operated by the right thumb, the AE-Lock button freezes the current exposure setting, allowing re-composition with no change to exposure. It's also used for in-putting Custom Function data, and can be re-programmed, via the Custom Function facility, to serve other functions, such as a depth-of-field stop-down button.

AF Auxiliary light emitter/Self-timer indicator

When light levels drop too low for the EOS5/A2/E's focusing system to work accurately on its own, the built-in AF Auxiliary light whirs into action and automatically emits a beam of red light, patterned to to match the focusing points. And when the self-timer is used, the same red light flashes repeatedly to indicate the last two seconds of the ten second delay. Say cheese!

AF Focusing Point Selection button

A small button that falls naturally under the right thumb and which you use to select the point(s) of focus of the Eye-Controlled Focusing system.

Autofocus Mode button

Recessed button on the camera back which, coupled with the Main Input Dial, lets you choose your preferred focusing mode.

2. Camera Rear View

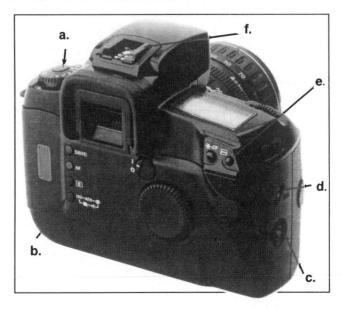

a. Command dial

b. Control buttons

c. Socket for remote release

d. Mid roll rewind button

e. AE Lock custom function button

f. Dedicated hot shoe for flash

Battery cover latch

Well-designed latch which allows you to open the battery compartment quickly and easily to replace the 6v lithium 2CR5-type battery. If you use the built-in flashgun a lot, you'll be needing it pretty regularly!

Built-in flashgun

Pop-up flashgun sited almost invisibly on top of the camera. Surprisingly powerful (GN of 13-17m/ISO100), with the ability to zoom automatically to match its coverage to lenses between 28mm and 80mm.

Camera back release

Simply push this switch down to open the camera back — but take a peek first to make sure you're not half-way through the best film you've ever taken!

Command Dial

One of the key controls on the Canon EOS5/A2/E — the chunky one on the top-plate which you use to select the shooting mode. Locks on the red "L" position, switching everything off, freezing all controls and preventing battery drain.

Dedicated flash/accessory shoe

Shoe mounted on the pentaprism at the top of the camera which accepts accessory flashguns. Is equipped with electrical contacts that give "dedicated" flash linkage with Canon EZ series flashguns.

3. CAMERA (top view):

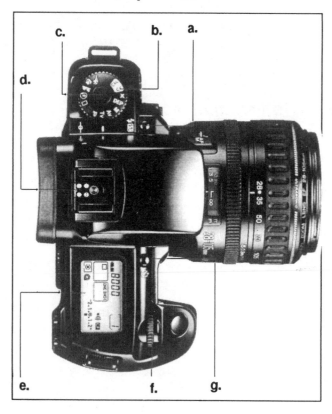

a. Pop up flash button

b. Command dial

c. Lock release button

d. Accessory shoe

e. LCD Information panel

f. Input dial

g. Self-timer button

Film identification window

Small rectangular window in the camera back which allows you to check what film – brand, type, number of exposures – is loaded.

Film drive mode button

Use this to choose how quickly you get through your film! 1 frame-per-second, 3 fps, or 5fps – it's up to you.

Flash PC synchronisation socket

Standard socket that allows the camera to be connected to off-camera flashguns, studio lights and other external flash units.

Flash Button

Press down to activate the built-in flashgun in Creative Exposure Modes. In Image Zone Modes the flashgun is programmed to pop up, a bit like a startled frog, fire automatically, and pop back down again, as and when needed. (On the EOS 5, but, sorry, not on the North American EOS A2/E, where you have to raise the flashgun manually in all modes).

Lens release button

Allows lens to be removed and changed for another. Hold the button down firmly and twist the lens anti-clockwise. Note: it is not necessary to hold the button down when fitting a lens.

4. CAMERA (Command Dial, close-up):

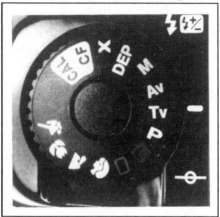

CAL Eye focus control

CF Custom function

X Flash sync. mode

DEP Depth of field

M Manual setting

AV Aperture priority

TV Shutter priority

P Program mode

▢ Red square lock position

▢ Green rectangle auto mode

 Portrait

 Landscape

 Close up

 Sports

Liquid-Crystal Display information panel

Important display on the camera's top-plate which keeps you informed about what the camera's doing. As busy as Times Square or Piccadilly Circus, but easy enough to understand once you've learned what all the icons and abbreviations stand for.

Main Input Dial

A stroke of genius from the boffins at Canon. This brilliantly-designed control, operated by the right-hand index finger, is one of the main reasons why this and other EOS cameras are such a pleasure to use and so popular. Serves many functions: on its own for selecting shutter speed/aperture combinations; with other controls as a versatile input dial.

Metering Pattern button

Take your pick of the camera's three metering patterns by pressing in this button and rotating the Main Input Dial

Multi-function button

Another bit of smart design: every press of this button sees a new function displayed on the top-plate LCD panel. There are five in all. Use it to set film speed, flash red-eye reduction, Auto–Exposure Bracketing, Multiple-Exposure, and audible bleep on/off.

Quick Control Dial

At first it looks a bit bizarre to find a big, round, thin dial on

the back of a camera where it's usually as flat as a pancake. But use the camera for a few minutes, especially if you're setting exposure compensation, and you'll appreciate how perfectly positioned it is.

Quick Control Dial switch

The last thing you want to do is dial in exposure compensation by accident, and this small control, best operated with a thumb, switches the Quick Control Dial on and off, to prevent mistakes. O is on, and I is off.

Red-eye reduction lamp

Small but immensely useful lamp next to the flashgun tube which lights up just before the flashgun fires, to minimise the likelihood of red-eye, the strange effect where people's eyes glow red, as if possessed by the Devil in some cheap 'B' movie. This is caused by the flash light being reflected back from the blood vessels at the back of their eye, and is most likely to occur when ambient light levels are low.

Remote shutter release socket

Plug in your optional Canon Remote Switch 60T3 to enjoy long exposures or avoid camera-shake by firing the camera's shutter without having to touch the camera.

Self-timer

Dinky button on the camera top-plate which sets the self-timer, giving you just 10 seconds to sprint around and put yourself in the picture. Mind you don't trip now!

Shutter release

How to be a Press Photographer in one easy lesson: put your finger on the shutter release and press!

Strap lug

Okay, so it's not particularly sexy, but you have to admit you'd be lost without somewhere to fix your strap.

User film rewind button

Half-way through a film and want to swap it for another? Stick your pinky in here then and get it rewound. Remember to choose Custom Function 2 first, though, to leave the leader out so you can re-load it. And make a note of how many frames you've exposed!

Rewinding film in mid-roll

Press the mid-roll rewind button to rewind the film. After the film is wound completely into the film cartridge, ⊕ blinks in the LCD panel.

Design and handling

Getting to grips with the Canon EOS5/A2/E

CANON'S PHILOSOPHY

Canon have a long history of blending design and technology very effectively, and much of that is down to the enormous emphasis the company places on the importance of research & development (R&D).

Indeed, I had the very great privilege not long ago of visiting Canon's R&D headquarters in Tokyo, Japan, and speaking personally to the design teams there. I was immensely impressed by the depth of their commitment and their dedication to making Canon cameras both better and easier to use.

They spoke with great passion about their desire to produce the perfect picture-taking machine, and of how they had set out to eliminate, one by one, systematically, the problem areas of photography.

Twenty-five years ago, cameras were very different from the way they are today. Single-lens reflex (SLR) cameras, in particular, were simpler, but also, paradoxically, more difficult to use.

Taking pictures was regarded by many as a complicated and arcane craft – a mixture of mystery and magic – on a par with walking on fire or sawing the lady in half. And far too often the pressing of the shutter release was accompanied by a barely audible sigh of "Here's hoping they come out". And far too often they didn't.

The first problem area that was tackled successfully was exposure. Older photographers will remember scratching their heads and trying to decide whether it was "cloudy

and bright" or just "cloudy". But the development of increasingly sophisticated light measuring systems swept all such difficulties aside and led to a situation where very few pictures now fail because of poor exposure.

People also had difficulty loading the film. Feeding the film leader into sprockets and winding on, with your thumb, via a film advance lever, was a fiddly business. And then, at the end, you had to remember to push in a button at the bottom of the camera and use the rewind crank to wind the film back into the cassette. Too many films to mention were never loaded correctly, with the result that the film never ran through the camera and a complete set of unrepeatable memories were lost forever. Others films were ruined when the camera back was opened before the film had been rewound. So automated film loading, winding and rewinding systems were introduced, and another problem area tamed.

The days when you had to ignite magnesium to take a flash picture are long gone, thank goodness, but flash photography remains a headache for more photographers than would care to admit it. Many, I'm sure, would much sooner eat their car than have to get into all that mumbo-jumbo about dividing the aperture into the Guide Number to give the camera-to-subject distance. It's not surprising then, that a lot of photographers suddenly found taking pictures by available-light and fast film very appealing in comparison.

Luckily once again the appliance of science has come to our rescue. First came computerised flashguns, followed by "dedicated" guns which interfaced with the camera's electronics, and finally built-in flashguns to make it all as easy as mom's apple pie.

Focusing has always been one of the areas of photography where people have had the most difficulty, so autofocus was introduced, first on compacts then on SLRs. Over time it got faster and more accurate. The hit rate improved but still a problem remained: people didn't always point the camera's autofocusing frame at the important part of the scene. Sometimes it would go between two heads, and focus on the background; other times it would just miss the subject entirely, if the subject was not in the middle of the frame. Clearly a whole new system was needed to make focusing even more foolproof.

Which brings us back, via what I hope you'll agree was an interesting detour, to the Canon EOS5/A2/E, which, with its Eye-Controlled Focusing system, is on a mission to make focusing errors a thing of the past. We will be going into the system in some depth in a coming chapter, where we'll be looking at how it works, how to set it up, and how to make the most of it.

Eye Controlled Focus detects the rotation angle of the photographer's eye. The system then calculates the photographer's line of sight by comparing the position of the pupil to reflection images created by a pair of miniature infrared emitting diodes (IREDs) mounted in the eyepiece frame.

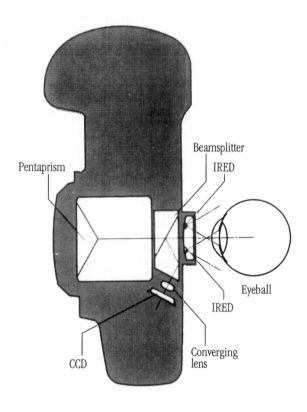

Beamsplitter

Pentaprism

IRED

Eyeball

IRED

Converging lens

CCD

Notice the quick control dial on the
camera back which is operated by
the right hand thumb.

This diagram also shows the data
back whereby you can imprint, if
required, the date or time on your
negative.

CHOICE AND CONTROL

But Canon hasn't simply sought to make cameras easier to use. An important part of the company's philosophy is that it should do so while still allowing the user as much choice and control as possible.

So although there are automatic exposure modes, the photographer can still select the aperture and shutter speed himself if he wishes; although there is autofocus, the lens can be focused manually if preferred; and the experienced photographer can still get into flash calculation if he wants.

This philosophy was surely stretched close to breaking point in the design of the Canon EOS5/A2/E. The camera has so many features on it that making it easy to use must have been a real nightmare. But necessity is, as they say, the mother of invention, and true to form Canon came up with some radical and exciting design solutions to keep the user in control.

Probably the most important innovation in the design of the EOS range as a whole is the invention of the Main Input Dial. This clever rotating wheel, sited near the shutter release, gives fingertip control over a multitude of functions when combined with other buttons dotted around the camera.

To extend versatility even further, some later models, including the EOS-1, EOS100/Elan, and now the EOS5/A2/E, also have a second, oversized, Quick Control Dial on the camera back, which is operated by the right-hand thumb.

The problem Canon had with the EOS5/A2/E was that even with two Input Dials they didn't have enough room to get everything into the camera they wanted, and still make it easy to operate. What could they do?

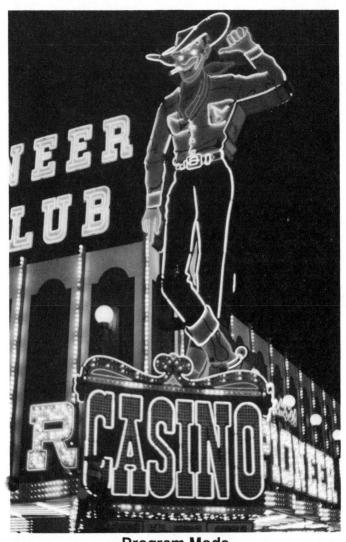

Program Mode

Photo : Steve Bavister

You can almost imagine some weary Japanese designer soaking away his worries in the bath at the end of a long day, then suddenly jumping up and shouting Eureka, or whatever the Japanese equivalent is — why not use the wasted space on the back of the camera to house some of the input buttons?

Once you've thought of the idea, of course, it's obvious. So, as strange as it looks at first sight, there's a vertical strip of 4 recessed input buttons on the back of the EOS5/A2/E. Use the camera for a short while, though, and have a play around with its many features, and you'll quickly realise what a stroke of genius it was using the camera back.

Everything is quick and easy to set and change, with the user staying in full control. Once again Canon's philosophy has been fulfilled.

HANDLING

Call it ergonomics, call it user-friendly design, call it what you like – but pick up the Canon EOS5/A2/E and the first thing you notice is how good it feels in the hands. Three fingers of your right hand wrap comfortably around the chunky handgrip while the right thumb presses into a curved panel to the right of the viewfinder to give a confidence-inspiring grip.

This leaves the right-hand index finger perfectly poised to fire the shutter and operate the Main Input Dial, and the right thumb ideally placed to turn the Quick Control Dial when necessary.

Of the other main controls, the top-plate Command Dial is best operated by the index finger and thumb of the left hand, while the camera-back input buttons are most easily accessed by either the left-hand index finger or thumb.

So the theory's good, what about the practise? How does the EOS5/A2/E actually handle when you're out taking pictures?

Of course there's a settling in period, where you get to know where everything is and what it's for, but once you've got through that it performs, in a word, like a dream. It becomes, as a good camera should, almost an extension of the photographer – not just a tool that he's using.

It can be operated single-handedly if required, and with gloves on. The buttons on the back are recessed sufficiently so that you don't catch them accidentally, but not so much that it's difficult to access them when you want to.

One way of recognising good design is in attention to detail. On most cameras, for instance, getting into the battery compartment is a necessary but unpleasant task.

You generally need a small coin to open it up but – guess what! – you don't have any change on you right now. So you try to use your fingernail...and naturally you end up breaking it.

You want to change the battery on the Canon EOS5/A2/E? Easy! Just turn the neatly-design latch, pull off the cover, and switch the battery. No hassle. All in about 20 seconds. Now that's good design.

Accessories are covered in more depth later in the book, but I can't let this section on design and handling pass without mentioning the degree to which the optional Canon VG-10 Vertical Grip improves the handling of the camera in the upright format. It looks a bit like a traditional autowinder and bolts onto the bottom of the camera, and is fitted with a duplicate set of the controls found on the standard grip: shutter release, Main Input Dial, AE-lock and Eye-Calibration button.

In many ways it's a shame the Vertical Grip wasn't built in as standard – although that would have increased the size, weight and price of the camera, so I guess Canon knew what they were doing after all.

THE VERTICAL GRIP

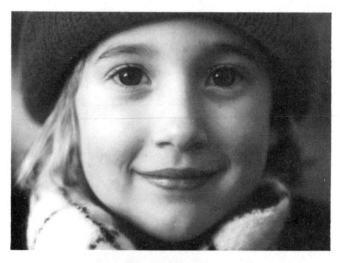

Taken with the relatively light EF
75-300mm zoom lens at f5.6
which weighs only 500g. In
comparison, the 300mm f2.8
weighs a staggering 2,855g!

TRAVELLING LIGHT

Talking of size and weight, Canon, like other on-the-ball companies, do lots of research into what their customers want – and one of the key things they learned at the end of the 1980s was that amateur photographers had a very strong preference for smaller and more lightweight cameras.

So, not surprisingly, that's what Canon set out to give them. They tasked their existing design team to come up with an EOS camera that was 30% smaller and lighter than existing models. They said it couldn't be done. So Canon formed a project team of young designers, believing that what they lacked in experience would be more than made up for by their open minds and willingness to try new things.

Canon EOS1000/Rebel

And they were right. To cut a long story short, the young design team succeeded, and the result was the Canon EOS1000 (US Rebel) – at the time of writing the best-selling SLR world-wide. The lessons learned in the creation of that camera were then incorporated into the cameras that followed, first the EOS 100 (US Elan), and now the EOS5/A2/E.

Given the specification of the EOS5/A2/E, and all the features it contains, including a 4.5 frame-per-second motordrive, the fact that it weighs in at just 665g (body only, no battery) is simply astonishing.

Of course, it is towards the top of the Canon SLR range, and has appeal to professional photographers as well as keen amateurs. For that reason it wouldn't do for it to be too light.

Professional photographers are just the opposite of amateurs, they like big and heavy cameras. Why? Because they feel more rugged and reliable. One of the ways in which Canon keep the weight of their cameras down is in their extensive use of polycarbonates and plastic.

Now some purists might turn their nose up at the thought of plastic, but the truth is that unless you regularly toss your camera into the back of your Jeep before heading off at high speed to your next location, or are a war photographer where the camera has to double as a bullet-proof vest, then plastic is fine.

Most amateur photographers love and cherish their cameras, and a plastic camera will last you every bit as long as a metal one. Naturally Canon haven't replaced all the metal with plastic. Important areas, such as the camera lens mount, which will see lots of wear, remain implacably metal.

In my experience, most of the problems that arise between people are the result of poor communication. So it is with cameras. If you want to take really good pictures, you need to know what is going on.

In this respect the Canon EOS5/A2/E is unrivalled, offering two main ways of staying informed: the LCD panel on the top-plate of the camera and an LCD strip which runs below the picture area in the viewfinder.

Both are clear, very easy to read, and work extremely well.

Some of the information they carry is the same, some different. Let us look at each in turn.

CANON'S QUIET REVOLUTION

One of Canon's key contributions to the art and science of camera design has been their development of "silent technology".

It's strange and intriguing how the world often turns full circle. Cameras always used to be quiet in operation. They had lenses you focused manually, a simple, silent shutter, and a thumb-operated lever you used to wind on the film. But over the years, with the addition of new features, cameras have become a lot more noisy.

An autowinder, with its distinctive chatter, now whisks the film through the camera. And a motor now helps the lens to focus, accompanied by its familiar and insinuating whir. These sounds have become such a taken-for-granted part of modern picture-taking that most of the time we're barely aware of them.

Canon's genius lay in recognising the obvious: that this noise pollution had reached a level where cameras could no longer be used in certain situations. At sports events or weddings, for instance, the atmosphere can be completely ruined by a badly-timed shot from a loud-mouthed camera.

Canon's conclusion was a simple one – that quieter cameras were needed. And they began what they call their quiet revolution. They developed a new coreless motor and belt drive system to advance the film accurately and in virtual silence, and they introduced a range of lenses with Ultrasonic Motors (USM) that focused quickly, accurately, and very quietly.

Fitted with its standard EF 28-105mm USM lens, the Canon EOS5/A2/E is one of the quietest cameras currently available. There are few situations where it will cause sufficient disturbance to make it unwelcome.

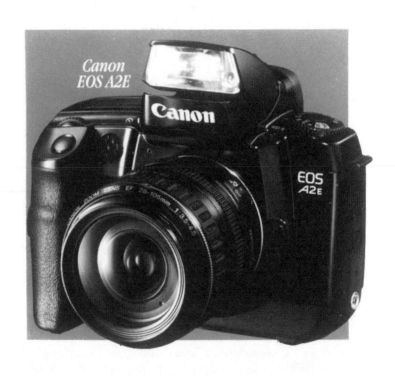

In the USA the EOS5 is known as the EOS A2E with eye-controlled focus.

Getting started - Shooting your first film

Unless you're a techno-maniac, who loves photographic equipment for its own sake (and nothing wrong with that!) you'll almost certainly have an overwhelming desire to get your first film loaded in the camera, shot, and processed, so you can show the resulting masterpieces to your family and friends.

That's entirely normal, but a camera as sophisticated as the Canon EOS5/A2/E is like a modern car: it's not so easy to just get into it and just drive away. To be sure of cornering safely and braking effectively you really need to know just what it's capable of beforehand.

But in the meantime, if you're so keen to start taking pictures that you don't have the time or inclination to read your instruction book or this one first, then here's a brief guide to getting your EOS5/A2/E on the road now.

INSERTING THE BATTERY

Like most modern cameras, the Canon EOS5/A2/E is wholly dependent on battery power, you clearly need to insert the battery before you can start taking pictures. This is done by turning the latch on the camera's handgrip and pulling away the battery compartment cover.

It should be obvious which way the battery goes in, with the electrical contacts at the bottom, pointing inwards. Pop the battery cover back on and take a peek at the top-plate LCD panel. In the top left corner you'll see an AA-battery-shaped icon which tells you how much power is left in the battery.

Assuming you've put the battery in for the first time, the

whole of the icon should be black, indicating that it's in good condition. If nothing is displayed, then you may have inserted the battery backwards. Progressively, as the camera is used, the icon will change to half black, then to empty, and when close to exhaustion will start blinking.

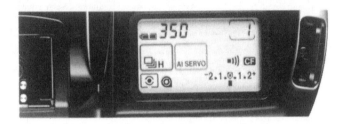

The actual life of the battery depends on a number of factors: see later in this book for full details of how to maximise battery life.

FITTING THE LENS

In its simplest form, a camera body is really nothing more than a light-tight container that holds the film – although, admittedly, in the case of the Canon EOS5/A2/E, a very sophisticated one!

Obviously the body alone won't get you very far, and you need to fit a lens before you can start taking pictures. If you've never done this before you might be a bit nervous about getting it wrong and messing something up. Actually there's no need to worry, as long as you take things carefully. Simply:

• hold the camera body in your right hand, with the lens mount pointing towards your left hand

- pick up the lens with the front element in the palm of your hand
- bring the two items together
- align the red dot on the lens with the red dot on the camera
- and twist the lens clockwise until you hear a click and the lens won't move any more

To remove the lens, first press in the lens release button, and then reverse the procedure outlined above.

LOAD THE FILM

To load the film, you must first move the Command Dial position to anything other than "L", otherwise nothing will happen. Then you simply:

- open the camera back
- insert the film cassette into the left-hand chamber upside-down
- hold onto the cassette with your left hand and use your right hand to pull the film leader across to the orange mark
- close the camera back, and
- check the top-plate LCD panel to ensure that the frame counter shows "1". If the film cartridge icon is blinking, the film has not been loaded correctly. Open the back, pull out the film leader a little more, and try again.

SWITCH TO GREEN RECTANGLE MODE

If you want to start shooting but can't be bothered right now to get to grips with the camera's phenomenal range

of features, then there's a simple solution: use the "Green Rectangle" mode. This is a picture-taking mode that's pre-set for general photography, and which will take care of all the technicalities for you. Select it by rotating the camera's top-plate Command Dial to the Green Rectangle position and you're ready to go.

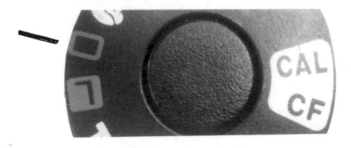

FIT THE STRAP

And finally, before you go out, fit the strap. For two reasons:

1. It's a lot easier carrying the camera around when it's got a strap on it, and
2. It's a lot safer. Cameras are more easily dropped with no strap, and it would be a great shame for you to have to cart your precious EOS5/A2/E back to your photo dealer for repair.

LET'S GO!

And so you're ready.

Pick the camera up, wrap three of the fingers of your right hand around the hand-grip, and let the fourth, the index finger, fall perfectly onto the shutter release button.

Put the camera to your eye and frame the scene before you.

Press down gently: feel the lens whizz into action, see exposure details appear in the viewfinder.

Squeeze the shutter release more firmly: hear the shutter fire satisfyingly and the film wind quietly on.

Congratulations! You've taken your first picture with your Canon EOS5/A2/E. Your first, but most certainly not your last.

STAYING INFORMED
LCD PANEL & VIEWFINDER

The more sophisticated a camera becomes, the more important it is that the photographer is kept informed as to what's going on.

In my experience most of the problems that arise between people are the result of poor communication. So it is with cameras. If you want to take really good pictures, you need to know what's going on.

In this respect the Canon EOS5/A2/E is unrivalled, offering two main ways of staying informed: the LCD panel on the top-plate of the camera, and an LCD strip which runs below the picture area in the viewfinder.

Both are clear, very easy to read, and work extremely well. Some of the information they carry is the same, some different. Let's look at each in turn.

TOP-PLATE LCD PANEL AT-A-GLANCE

This camera uses a large liquid crystal display panel to display shooting information. The diagram below shows all the information displayed simultaneously for explanation only. The LCD panel never actually appears like this.

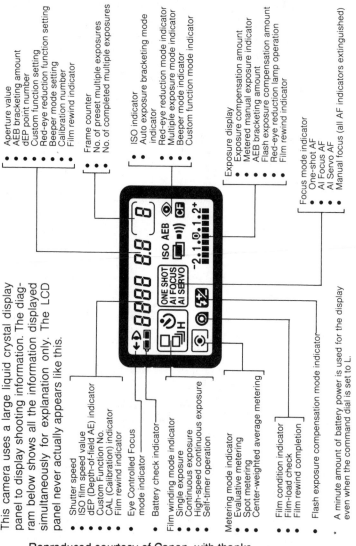

Aperture value
AEB bracketing amount
dEP point number
Custom function setting
Red-eye reduction function setting
Beeper mode setting
Calibration number
Film rewind indicator

Frame counter
No. of preset multiple exposures
No. of completed multiple exposures

ISO indicator
Auto exposure bracketing mode indicator
Red-eye reduction mode indicator
Multiple exposure mode indicator
Beeper mode indicator
Custom function mode indicator

Exposure display
Exposure compensation amount
Metered manual exposure indicator
AEB bracketing amount
Flash exposure compensation amount
Red-eye reduction lamp operation
Film rewind indicator

Focus mode indicator
One-shot AF
AI Focus AF
AI Servo AF
Manual focus (all AF indicators extinguished)

Shutter speed
ISO film speed value
dEP (Depth-of-field AE) indicator
Custom Function No.
CAL (Calibration) indicator
Film rewind indicator

Eye Controlled Focus mode indicator

Battery check indicator

Film winding mode indicator
Single exposure
Continuous exposure
High-speed continuous exposure
Self-timer operation

Metering mode indicator
Evaluative metering
Spot metering
Center-weighted average metering

Film condition indicator
Film-load check
Film rewind completion

Flash exposure compensation mode indicator

* A minute amount of battery power is used for the display even when the command dial is set to L.

Reproduced courtesy of Canon, with thanks

42

VIEWFINDER INFORMATION PANEL AT-A-GLANCE

The diagram below shows all the information displayed simultaneously for explanation only. The viewfinder never actually appears like this.

Depth-of-Field
Check mark
Matte screen
AF frame indicators

Flash exposure compensation mode indicator

In-focus indicator (During autofocusing: Lights when subject is focused, blinks at 8 Hz when focus is impossible. During manual focusing: Lights when subject is focused, extinguished otherwise.)

Exposure display
● Exposure compensation amount
● Manual exposure level
● AEB bracketing amount
● Red-eye reduction lamp operation indicator

Aperture value

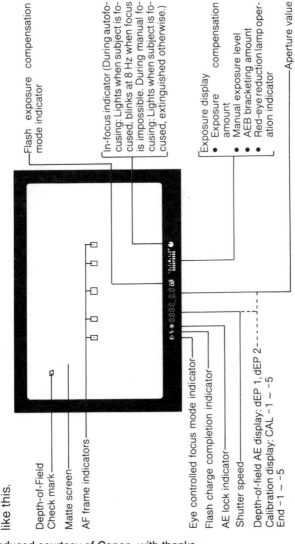

Eye controlled focus mode indicator
Flash charge completion indicator
AE lock indicator
Shutter speed
Depth-of-field AE display: dEP 1, dEP 2
Calibration display: CAL −1 ~ −5
End −1 ~ −5

Reproduced courtesy of Canon, with thanks

TOP-PLATE LCD
(LIQUID-CRYSTAL DISPLAY) PANEL

The top-plate LCD (Liquid-Crystal Display) panel on the Canon EOS5/A2/E really is an incredible piece of design. It's hard to imagine that a black on white panel just 20mm x 35mm can carry such a wealth of information about 19 different functions – without it getting confusing.

Of course, until you get used to it and learn what all the various icons represent, the panel does look a little daunting. But it doesn't take long to get to know the most important parts of the display – less frequently used information you can look up as and when you need it.

A trend in LCD design found on the Canon EOS5/A2/E is that a significant amount of the information is conveyed by means of icons, that is symbols which represent functions and features on the camera. For instance [◉] – for Evaluative Metering – indicates that evaluative metering is set.

So without more ado, let's have a look at all the things you can learn about what the camera's doing by checking out the top-plate LCD panel.

TOP-PLATE LCD INFORMATION

With the Command Dial locked in the "L" position, and the camera effectively switched off, you have a limited amount of information available to you.

The key thing you can tell at a glance is whether or not the camera is loaded with film. If it's empty, the LCD panel will be blank apart from two rectangular panels. If the

camera has got a film in it, you'll see a small round icon, like a film cassette viewed from the top, along the bottom left-hand of the LCD. You'll also observe a figure in brackets in the top right corner which indicates the number of pictures already taken.

Switch the Command Dial to any of the camera's exposure modes, and you'll see the top-plate panel come alive. Both the film loaded icon and the "pictures taken" number remain visible, but there is also a wealth of additional information.

Much of the technical skill in taking pictures lies with the creative choice of aperture and shutter speed, so it's crucially important that the photographer is kept fully informed what's happening exposure-wise. Canon's designers are obviously very keen photographers themselves, because they've quite rightly made sure that the aperture and shutter speed figures are the biggest and clearest thing on the top-plate panel.

The apertures run in half stop increments, in the standard sequence of f/1, f/1.4, f/1.8, f/2, f/2.5, f/2.8, f/3.5, f/4, f/4.5, f/5.6, f/6.7, f/8, f/9.5, f/11, f/13, f/16, f/19, f/22, f/27, f/32, and are displayed as simple digits, i.e. 4.5 or 16. The precise range of apertures available will be determined by the lens fitted to the camera.

The shutter speed range of the Canon EOS5/A2/E is an extensive one, from an action-stopping 1/8000 sec to a night-scene-capturing 30 seconds.

Fractions of a second (i.e. 1/2 sec to 1/8000 sec) are displayed as equivalent numbers – so 1/2 sec is shown as 2, and 1/8000 sec as 8000.

Speeds of one second or longer are displayed as the time followed by a double apostrophe – so one second appears as 1", and 30 seconds as 30".

For most people it takes no more than a couple of rolls

of film to get used to how the apertures and shutter speeds are displayed. After that, they can see at a glance the situation on the exposure front.

Fine-tuning exposure is quick and easy on the Canon EOS5/A2/E using the well-designed exposure compensation system. This is indicated on the bottom right hand side of the top-plate as a range of numbers from -2 to +2. To set the degree of exposure compensation required, use the 0/1 switch on the camera back to activate the big Quick Control Dial. Then, as you rotate this, you'll see the black cursor on the display move back and forth. When you've taken your series of compensated pictures, use the Quick Control Dial to return the cursor to the 0 position and use the lock once again – to ensure that compensation is not set by accident.

Similar exposure compensation can also be applied to the built-in flashgun, simply by pressing the flash activation button to the left of the pentaprism. The procedure is the same as above.

In the top-plate LCD panel there are two rectangles. The one on the left, bordered in blue, is used to indicate the camera's drive status. At any one time it will be showing one of three things:

□ – to indicate Single Shot

⊒ – to indicate Continuous film advance (up to 3 frames-per-second)

⊒H – to indicate High-speed Continuous film advance (up to 5 frames-per-second).

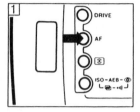

To change from one Drive Mode to another, simply press in and hold the Drive button on the camera back. You'll see the top-plate display clear of everything but the drive information in the blue rectangle. Rotate the Main Input Dial and you'll see the above icons appear one by one. When you see the Drive Mode you want displayed, simply release the Drive button and it's set until you want to change it again.

To the right of the blue rectangle is another rectangle, which displays details of the autofocus mode that has been selected. It will show one of three things:

- One shot – to indicate One-Shot focusing mode
- AI Servo – to indicate AI Servo focusing mode
- AI Focus – to indicate AL Focus focusing mode
- Nothing – to indicate that the lens is being focused manually

One-shot and AI Servo are both selected by holding in the AF button on the camera back, spinning the Main Input Dial until the appropriate mode is displayed, and then releasing the AF button. Please note that AI Focus, which automatically selects One-Shot AF or AI Servo AF by detecting subject movement, cannot be selected directly

by the user. It is part of the Green Rectangle package, and is only used and displayed when that mode is chosen.

In the bottom left-hand corner is a small rectangle, broken in the middle at the bottom. This tells you which metering option has been chosen. It will show one of three things:

⊡ – for Evaluative Metering

⊡ – for Spot Metering

⊡ – for Centre-Weighted Average Metering

To change metering patterns simply push in and hold the second button up on the camera back, rotate the main Input Dial, and release when the appropriate icon appears on the display.

The bottom button on the camera back is multi-functional, when it is used with the Main Input Dial it calls up a range of top-plate LCD displays.

The first press brings up the Multiple-Exposure display, consisting of this icon ▦ and a number 1. Rotating the Main Input Dial changes the number to indicate the number of multiple-exposures required – up to a maximum of 9. You opt, for instance, to put 5 exposures on one frame by selecting 5. After a few seconds the display returns to normal, but with the figure five in the top right-hand corner where the number of pictures taken would normally be shown, and the multiple-image icon also shown. Then, as you take your multiple-exposures one by one, the camera counts down for you, 4, 3, 2, and 1. After the first shot has been taken the multiple-

exposure icon flashes on and off, to remind you that you're in the middle of a series of multiple-exposures. Once the cycle is complete, the display will return once again to normal – unless you've already opted for Custom Function 8 (see later for fuller explanation), in which case the multiple-exposure cycle will start again.

A second press on the bottom button has the display showing the speed the film in the camera is currently being rated at. This will be between 6 and 5000 ISO.

The full range runs in one-third stop increments, as follows: 6, 10, 12, 16, 20, 25, 32, 40, 50, 64, 80, 100, 125, 160, 200, 250, 320, 400, 500, 640, 800, 1000, 1250, 1400, 1600, 2000, 2500, 3200, 4000, 5000, 6400.

To change film speed, call up the ISO display, rotate the Main Input Dial until the film speed you require is shown, and release the button. After a few seconds the display will return to normal. Please note, though, that unless Custom Function 3 has been set, cancelling the automatic film speed setting via the DX-coding system will cause any change to the ISO rating to last only for the film in the camera. As soon as a new film is loaded, the DX-coding system will over-ride any previous rating.

A third press on the bottom button calls up the camera's sophisticated Auto Exposure Bracketing (AEB) system. This allows you to take three successive pictures in the following sequence:

1. Correct exposure
2. Under-exposure
3. Over-exposure

It's up to you to choose how much under- and over-exposure you want to give. On the AEB display you'll see a range at the bottom from -2 to +2, together with a digit at the top between 0 and 2. Rotate the Main Input Dial and you'll see the top digit increase in half stop intervals, while the lower display fans out accordingly. So if you want to bracket at one stop intervals, set 1 at the top. After a few seconds the display will revert to normal, except that AEB will now be visible, and the spread of bracketing will be shown on the Exposure Compensation display (bottom right). As you take your bracketing series, that display will flash until the sequence is complete. To cancel AEB, press the bottom button once again and use the Main Input Dial to go back to 0.

A fourth press on the bottom button on the camera back accesses the flashgun's built-in red-eye reduction system. The display shows a solitary eye on the right-hand side, and either a 0 or a 1 at the top. A '0' indicates that the red-eye reduction system is switched off; a 1 that it's on. To change from 0 to 1, or vice-versa, simply use the Main Input Dial in the usual way. Once the display has returned to normal, you can check whether red-eye reduction has been set or not: if it has, the eye will still appear on the right-hand side of the LCD.

A fifth and final press gives you the chance, if you wish, to cancel the camera's audible beep, which is used to confirm focus and give warning of possible camera-shake. Once again this is a 0/1, on/off system, operated by the Main Input Dial.

If you've set any of the camera's 16 Custom Functions (see later for full details), you'll see the letters CF coming out of a black rectangle to remind you.

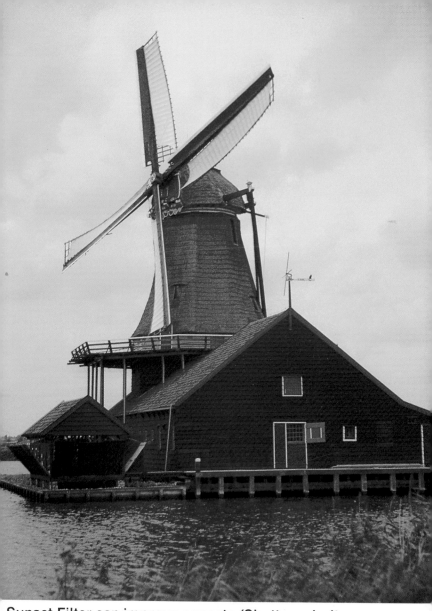

Sunset Filter can improve sunsets (Shutter priority AE)

Photo Steve Bavister

Slow shutter speed with T.V. *Photo Steve Bavister*

Note how the white paper has reflected the light onto the child's face. *Photo Steve Bavister*

Unexpected - EOS5 in program mode ready for action.
Photo Steve Bavister

"If only statues talked". Look for the unusual.
Photo Steve Bavister

Bracketing your shots. Top left +2 stops, right +1 stop
bottom left correct right -1 stop. *Photo Steve Bavister*

Ultra sharp lenses. AV (Aperture Priority AE).

Photo Steve Bavister

Circular polarising filter to darken the sky.
Photo Steve Bavister

Use of "bulb" setting catches the fireworks display.
Photo Steve Bavister

On camera flash has many uses on the **EOS5/A2E/A2**.
Photo Steve Bavister

Look at the top left-hand corner and you'll find an interesting looking icon consisting of an eye and an arrow. As you might imagine, this confirms that the camera is set up for Eye-Control Focus.

And just below it, to make sure you don't run out of power unexpectedly, there's a battery check, which gives you some idea of how much oomph the battery has left.

Want to use the self-timer? Press down the button marked \circlearrowleft to the left of the Main Input Dial, and you'll see a similar icon appear in the blue rectangle on the top-plate display. The self-timer will then remain active until the button is pressed again, when the icon will disappear from the display.

VIEWFINDER INFORMATION

Designers of viewfinder information panels have a tricky job to do. On the one hand, they have to make them clear and easy to read, yet on the other they must take care not to distract attention away from the viewfinder image itself.

Thankfully, in the Canon EOS5/A2/E, the designers have got it just right. Forget the frantic, but necessary, "disco fever" of the top-plate LCD. The information panel in the viewfinder, a long, thin strip along the bottom of the picture-area, is a model of sparseness and simplicity. With yellow numbers reading out of a background of green, the viewfinder LCD is very relaxing and pleasant to look at, yet presents its information with tremendous clarity.

The viewfinder display panel is switched on first by placing pressure on the shutter release, and then in normal use it stays visible for six seconds after the pressure has been released. However, you can, if you wish, conserve battery power by means of Custom Function 13, which programs the display to disappear as

soon as the pressure is taken away.

The viewfinder itself is bright, clear, and shows 92% vertical and 94% horizontal of the actual picture-area.

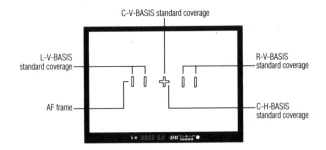

Once again, the two things you really need to know when you're taking a picture are the aperture and shutter speed. Anything else is useful, but secondary. If anything, it's more important that exposure information is clearly displayed in the viewfinder, because the last thing you want to do is to have to keep taking your eye away from the viewfinder to check something on the top-plate.

And once again, Canon have got it just right. Clear, bold numbers, following the style of those on the top-plate, tell you at-a-glance just what the aperture and shutter speeds are.

We have already, when discussing the top-plate LCD above, talked about what a fiddly business exposure compensation is on most cameras, yet how comparatively simple it is on the Canon EOS5/A2/E. One of the reasons for the system's success is that you can set the required compensation without having to remove your eye from the camera. Look at the right hand side of the viewfinder information strip and you'll see a copy of the exposure compensation display on the top-plate LCD. And as you make fine-tuning exposure adjustments, operating the

over-sized Quick Control Dial with your thumb, you can keep pace with what's happening in the viewfinder. Note: the North American A2 and A2E use a different, +/− display.

Much of the design of the Canon EOS5/A2/E seems to have been modelled on the Chameleon, with controls capable of changing character at a moment's notice. Switch the Command Dial to Manual Exposure, for instance, and the viewfinder compensation dial suddenly transforms itself into a modern electronic version of the old matched-needle metering system, complete with a flashing cursor to highlight over- or under-exposure.

This happens once again, when the camera's integral flashgun is brought into use. The viewfinder compensation display will then magically transform itself into yet another type of display, one which shows the flash charging up and ready to fire. Incredible! A lightning strike icon also appears on the left-hand side of the viewfinder LCD, to confirm flash is being used.

When the lens comes to focus, following pressure on the shutter release button, one or more of the red, square, AF Frames lights up in confirmation, followed shortly after by a yellow circle at the extreme right-hand side of the green viewfinder LCD. Now at first sight it seems a bit pointless having both the frames and the circle lighting up, since they seem to do the same thing. You want to say, "Come on Canon, admit that you've slipped up here, and one of these means of confirmation is unnecessary!" Well, alas, first impressions can be misleading, and Canon are, as usual, ahead of the game. One of the Custom Function options, CF10, is to stop the AF frames from lighting up − so you do need to have the circle as well, to still provide confirmation of focus.

When the AE-Lock button, which falls underneath the

right thumb, is in use, an asterisk appears at the left of the viewfinder LCD strip. Please note: the AE-Lock button can be re-programmed using the Custom Functions to perform a range of other tasks.

The viewfinder is also, as we shall see in the next section, essential for the calibration of the Canon EOS5/A2/E's unique eye-controlled focus.

VARIABLE DIOPTER EYEPIECE
CANON EOS A2 AND A2E ONLY

Variable diopter: On the EOS A2 and A2E, a built-in variable diopter adjusts from -2.75 to +0.75 dpt., operated by an 8-position slide switch above the viewfinder eyepiece.

EYE–CONTROLLED FOCUS
SEEING IS BELIEVING

Imagine a camera so sophisticated that it could tell which part of the scene you're looking at and automatically focus there.

Science fiction? The product of an overactive imagination? So we used to think. Now, suddenly, as in many other areas of our lives, we wake up one morning to find that yesterday's science fiction story is today's reality, and what we used to think of as tomorrow's technology can be bought in the shops this very afternoon.

And as for that camera which knows where you're looking – you can stop imagining. It's here already – and you're probably holding it in your hands right now.

That the Eye-Controlled Focus system on the Canon EOS5/A2/E is a technical tour-de-force is not in doubt. Nothing like it has ever existed on a production camera before, it is a genuine first, and a dramatic step forward in autofocusing systems. In a moment we'll talk in some depth about how well it works, but first we'll just get an overview of what focusing options there are on the camera.

CHOICES

As in all other areas of the EOS5/A2/E, Canon offer you plenty of choices in the focusing department. While many users will undoubtedly want to take advantage of the revolutionary Eye-Controlled Focusing system, you don't have to if you don't want to. Here's the complete menu of focusing options:

- Full Eye-controlled focus, in which the camera recognises by reading from your eye which part of the picture you're looking at and automatically focuses there.
- If you prefer, you can nominate just one focusing point, which you then use as you would on any other autofocus SLR. But the difference is that the focusing point doesn't have to be in the middle – any of the five points can be chosen.
- Another alternative is to let the camera focus automatically for you, using its "intelligence" to determine which of the point(s) to focus on.
- Or you can always focus manually, if that's the way you'd like to work.

We'll be looking at each of these four options in more depth over the next few pages, but first it will be useful to understand a bit about how the camera achieves all these miraculous feats.

Before we start tucking into the meat of the matter though, I'd just like to make it clear that this is not intended to be a deeply technical book, so it won't be going into great detail about the science and technology of Eye-Controlled Focus. That is not its purpose.

I use a computer every day, for word-processing and number-crunching, but I have absolutely no idea how it works – nor am I really interested beyond a very basic level. All I want to know is what it's capable of, and learn how to operate it sufficiently well to get the very best from it.

I believe that most people interested in photography feel the same way about cameras – they're a means to an end, not an end in itself. So in looking at Eye-Controlled Focus I shall be considering what it is, how to use it, and

offering some advice on ways of harnessing its potential to help you take better pictures.

HOW IT WORKS

Having said all that, when you get down to it, the principles of Eye-Controlled Focus are pretty simple anyway. Within the viewfinder eye-piece are infra-red light-emitting diodes (iREDs) which illuminate the photographer's eye, with the light that's bounced back being picked up by a CCD infra-red area sensor, which analyses the pattern of reflection to determine where the eye is looking.

Now the idea of having infra-red radiation fired into your eyes from a very close distance might well get you a bit edgy – but there's no need, the output is very low indeed, and well within Internationally-agreed safety levels.

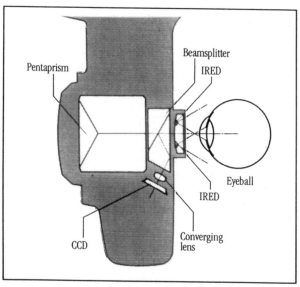

Pentaprism

Beamsplitter

IRED

Eyeball

IRED

CCD

Converging
lens

HOW TO CALIBRATE THE EYE-CONTROLLED FOCUS

Before you can start using the Eye-Controlled Focus system you have to first calibrate it for your eye. That may sound a bit daunting, but don't be put off – it's easy to do and quick as well. All eyes are different, and before the system can recognise where you're looking, it has to get to know the characteristics of your eye.

Here's how to do your calibration:

1. Rotate the Command Dial to the "CAL" position, and the top-plate LCD panel will show a number between 1 and 5, indicating the five "calibration channels" available
2. If the number is flashing, it means that channel is free; if it's not, you need to turn the Main Input Dial until you find a number that is flashing. If you can't, press in the AE-Lock button and Eye-Focus Select button together, and it will cancel all previous calibrations on that channel, and the number for it will start flashing.
3. Find a location where there is good light, but where your eye is not in direct sunlight, look into the viewfinder, and you'll see the right-hand AF frame flashing red. Fix your stare on it, and press the shutter release down as if you were actually taking a picture, you'll hear a beep of confirmation, and
4. Then the left-hand AF Frame will start flashing. Stare at it once more, and then press the shutter release again. Once more you'll hear a beep, and the word "End" will appear in both information panels.

And that's it! Calibrated! You can if you want repeat the process on your channel, because every time you do it the

camera builds up more data on your eye and so increases its accuracy. All you have to do is remember which channel you've done, because you'll obviously want to return to take pictures with it. Once you've committed it to memory, turn the dial to Portrait Automatic mode, and give the Eye-Controlled Focus system a trial to see if it works. If not, check through the trouble-shooting guide below.

If you sometimes wear glasses or contact lenses, then you may wish to calibrate yourself with and without. It's essential that you do this on separate channels.

Similarly, if you have someone else who will be using the camera on a regular basis, get them to use a different channel.

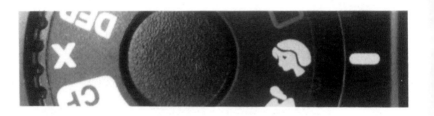

WHAT TO DO IF YOU HAVE PROBLEMS CALIBRATING THE EYE-FOCUS SYSTEM

Try again. Things to check for:

- Is your eye right in the middle of the viewfinder eyepiece – i.e. can you see all four corners of the picture?
- Is your eye "square" to the camera – i.e. you're not looking from above or one side?

- If you wear glasses, have they changed position at all?
- Is your eye in direct sunlight – if so, calibration is not possible
- Are you holding the camera steady enough?

HOW TO SELECT EYE-CONTROLLED FOCUS

Eye-Controlled Focus is selected, and de-selected, by means of the Eye-Select button by the thumb of the right hand, represented by five dots in a rectangle. Press that in, turn the Main Input Dial, and wait until you see an icon of five squares flashing. Press the shutter release lightly, and it's set. If you prefer at any time to switch the eye-control function off, then switch the Command Dial to "Cal" and turn the Main Input Dial until the word "Off" appears.

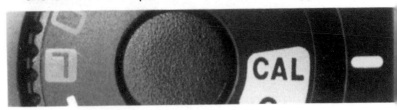

EYE-CONTROLLED FOCUS IN PRACTICE

Eye-Controlled Focus is such a magical and mind-boggling development that the first few times you use the Canon EOS5/A2/E you'll find yourself paying so much attention to the technology that you forget all about taking pictures.

Like a cautious driver checking his brakes regularly as he goes down a steep hill, you'll keep trying out the Eye-Controlled Focus, just to make sure it's working. And, if

you're anything like me, you'll try to catch the system out, to see how good it really is. Well, it's only human nature, isn't it?

Left, middle, right, middle, left, middle, right – your eyes won't have seen this much exercise since the last time you went to Wimbledon or Flushing Meadows. Then left to right really fast – let's test those limits.

How well does it perform? Try it yourself! For me, and for most other people I know who have used the camera, the Eye-Controlled Focus system works very well indeed, responding quickly and accurately in the majority of situations. Of course the system's not perfect, so maybe now's the time to have a chat about what its limitations are.

THE LIMITATIONS OF THE SYSTEM

As you'll have discovered, the principal problem with the Eye-Controlled Focus system is that while it works horizontally, it won't work vertically. That is a shame, admittedly, because it would undoubtedly be an advantage to be able to turn the camera on its side and have it follow the focus of your eye. But technically it's not possible right now, so we'll all just have to learn to live within its limitations. All the other focusing choices work in the upright position.

The system also won't work for everyone. Some people, despite following all the rules above for trying to calibrate, just find it impossible.

And a final, small but niggly point, is that you have to take your finger off the shutter release and reapply it to re-select the focusing point. It would have been quicker and easier if the finger could stay on the release while the eye roams around the viewfinder.

LETTING THE CAMERA FOCUS FOR YOU

Another option is to let the camera decide where to focus for you. What happens is that all five focusing points are "live" – even when the camera's turned upright! – and it uses all its stored bank of memory to figure out where to focus.

Here's how to do it, you:

1. Rotate the Command Dial to the "CAL" position
2. Turn the Main Input dial until "OFF" shows in the top-plate LCD panel
3. Rotate the Command Dial again, to any Creative Exposure Mode position (P, Tv, Av, M, Dep)
4. Press and hold in the AF Focusing Point Selection button
5. Spin the Main Input Dial until the top-plate LCD panel shows a display with all five focusing points flashing on and off at the same time, and
6. Release the AF Focusing Point Selection button. After a few seconds the viewfinder will return to normal, and Five-point automatic focusing will have been set.

Now you'd probably imagine the camera would make a right pig's ear of focusing by itself. After all, it can't read your mind and know what you think is the important part of the scene, can it? So the chances are that it will get things wrong as often as it gets them right – right?

But not so. Mind-reader or not, the Canon EOS5/A2/E gets it right a surprisingly high percentage of the time, invariably picking the point that I would have chosen myself. In fact, problems only really occur when you're trying to do something clever or creative, such as wanting

the background in focus when there's a large object in the foreground.

But anyway, you can see clearly in the viewfinder which point(s) the camera has focused on, because the AF frames that have been used light up red. And if you don't like where it's chosen to focus, no problem, you can simply over-ride the system.

CHOOSING ONE FOCUS POINT

Perhaps, for whatever reason, you don't want to use the Eye-Controlled Focusing system. Maybe you find it a little "gimmicky" Or you take a lot of upright pictures, when it won't work. Or you simply prefer to have just one focusing point.

Well that's just fine and dandy. Every need, every taste, is catered for on the Canon EOS5/A2/E. But here's the clever bit. On other EOS cameras your focusing point is fixed in the middle of the viewfinder. That's just where you want it most of the time, but it does mean that when the important part of the picture is off-centre you have to focus on the subject, press down on the shutter release to lock focus, and then re-frame the picture to give the composition you want. Now admittedly this is not exactly an arduous way of working, and those of us who've used autofocus cameras for the past few years have got used to it.

But if there's a better way, why not go for it? Say, for instance, you shoot a lot of portraits, with the camera on its side to give an upright format. Then you'll probably find it works out a lot better if you make the focusing sensor at the far right-hand side "live", so that it lines up with your subject's face in a three-quarter shot. Neat, eh?

To set this up you first have to switch off the Eye-Controlled Focusing System, if it's on. Here's how:

1. Rotate the Command Dial to the "CAL" position
2. Turn the Main Input dial until "OFF" shows in the top-plate LCD panel, then:
3. Rotate the Command Dial again, to any Creative Exposure Mode position (P, Tv, Av, M, Dep)
4. Press and hold in the AF Focusing Point Selection button
5. Spin the Main Input Dial and the top-plate LCD panel will show in turn five possible positions for the autofocus sensor. Select the one you want
6. Release the AF Focusing Point Selection button. After a few seconds the viewfinder will return to normal, and you'll have chosen a single point of focusing, according to your preference.

FOCUSING MANUALLY

Given that Canon have concentrated their attention in the EOS 5/A2/E on the sensational and innovative Eye-controlled focus, you'd be forgiven for thinking that manual focusing was probably a bit of an afterthought – and not very good.

But that's not Canon's way. They seek to make their cameras perform with excellence in every area – which is one of the reasons why they enjoy the pre-eminent position in the SLR market that they do.

In fact, the manual focusing on the EOS5/A2/E is exceptional, as it is on other EOS cameras. The viewfinder image is clear and bright, and you still have the benefit of the yellow circle in the viewfinder LCD strip which lights to confirm focus. To switch to manual focusing all you have to do is slide the switch on the lens marked AF/M back towards the camera, to the M position, and then turn the serrated focusing ring on the lens.

Why would anyone want to focus manually when autofocus is now so good? Especially when they have at their disposal a camera with a state-of-the-art autofocusing system that the EOS5/A2/E is equipped with?

There are several good reasons:

- Maybe they shoot a lot of fast sport and action, and like to pre-focus – i.e. focus on a point and wait till the action comes into it – which it's easier to do in manual
- Or perhaps because they're used to manual focusing, they like it, and simply prefer to stick with it.

EYE-CONTROLLED FOCUS – WHERE NEXT?

Every time there's innovation in the photographic marketplace you can be sure the pundits will be there putting it down as a one-way trip down a technological cul-de-sac. They pooh-poohed built-in-exposure and metering systems, they scoffed at autofocus, they turned their noses up at built-in flashguns. And time and time again they've all been proved wrong.

Eye-Controlled Focus is not a gimmick, but a major step forward in camera design. The Canon EOS5/A2/E is the first of a whole new breed of interactive cameras. Future EOS cameras will certainly work vertically, and they're likely to have more focusing points. But think ahead a bit more and it's reasonable to anticipate that other features will be selected by eye alone.

Who knows where it might end? Maybe it won't be long before we'll be changing mode/drive or giving exposure compensation – all by eye.

If you can imagine it, then it's coming. And I for one can't wait.

AUTOFOCUS OPTIONS
THREE WAYS TO SHOOT

Whichever way you set the Canon EOS5/A2/E up, using the Eye-Controlled Focus system or not, you'll find the camera focuses with startling rapidity, far quicker than even the most-experienced professional could ever hope to achieve manually.

Not only is it fast, especially with USM (Ultrasonic Motor) lenses, it's also incredibly accurate. In fact it's fair to say that autofocus has improved the overall quality of picture-taking enormously. It's especially a great boon for people with visual difficulties – and from the age of 40 most people start to see a steady deterioration in the quality of their vision.

So thank goodness for autofocus, and thank goodness in particular for the Canon EOS5/A2/E, which offers photographers three autofocus options: One Shot mode, AI Servo mode, and AI Focus mode. Here's how to set them:

1. Press in and hold the button marked AF on the camera back
2. Turn the Main Input Dial. You'll see, on the top-plate LCD, the rectangle in the middle change from "ONE SHOT" to "AI SERVO"
3. Release the AF button, and after a few seconds the display will return to normal, with the option displayed now selected

Please note: the AI FOCUS mode cannot be user-selected. It is only available in the Green Rectangle mode.

Also note: you can only change between AF modes when the lens on the camera is switched to the AF position. If it's in manual, it won't work.

WHAT THE FOCUSING OPTIONS ARE AND WHEN TO USE THEM

ONE SHOT

Most of the time, for general picture-taking, it's probably the One Shot mode that you'll choose. Simply press the shutter release part of the way down and the lens will focus, and will stay focused, on that point until you take the pressure off the shutter.

One important benefit of this mode is that you can't take a picture until the camera has successfully focused – and that means it's very difficult to take out-of-focus pictures.

Sometimes, if the subject has very little contrast or light levels are low, the lens will find it difficult to focus. In those situations, see if you can find something the same distance away from the camera which has more contrast, because that's what the camera's autofocus system needs to "bite" on.

AI SERVO

If it's the One Shot mode you'd use for static subjects then it's the AI Servo mode you'd choose for moving subjects. Here, for as long as pressure is applied to the shutter release button, the lens will continuously focus and re-focus as necessary.

Not only that, it also has predictive ability, in that it can calculate the speed and direction of the subject. Yes it's true! The problem is that there's a delay, just a short one, between the pressing of the shutter release, the mirror flipping up, and the shutter actually opening and then closing. For static subjects it's not a problem, but with fast-moving subject it is, because by the time the shutter has opened your subject has moved, and it will be out of

focus.

With the Canon EOS5/A2/E you have no such problem. The system automatically calculates where the subject will be, and sets focus accordingly, for perfectly-sharp pictures every time. The automatic tracking works at up to 3 frames-per-second.

The only real drawback of the AI Servo system is that it is possible to take a picture that's out-of-focus.

AI FOCUS

The AI Focus is a special mode which cannot be chosen directly by the user. It appears only as part of the package of features that make up the Full Auto Green Rectangle mode. What it does is switch automatically between One Shot and AI Servo as necessary. That is, for normal, everyday picture-taking it opts for One Shot, changing automatically to AI Servo when it senses subject movement.

EXPOSURE
UNDERSTANDING THE PRINCIPLES

The principles of exposure are simple enough. The film in your camera is sensitive to light. Moreover, it has been prepared in such a way that it needs a very specific amount of light to fall on it so that when it is processed a good picture results.

Exposure is all about putting that right amount of light onto the film. At your disposal you have two controls, the aperture and the shutter, each of which can be used to let through a controlled amount of light.

LENS APERTURE CHART

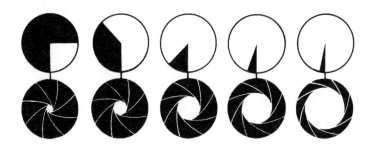

The aperture is nothing more than a hole in the lens whose size can be varied, and apertures are marked with a strange and baffling series of numbers, called f-numbers or f-stops: f/1.4, f/2, f/2.8, f/4, f/5.6, f/8, f/11, f/16, f/22, f/32. There are five key things you need to understand about apertures:

1. that, confusingly, the low numbers describe big holes, and are called big or wide apertures, and the high numbers describe tiny holes and are called small or narrow apertures,
2. that each progression along the scale represents a doubling or halving of the light let in, so f/5.6 lets in twice as much light as f/8 but only half as much as f/4.
3. that each doubling or halving of light is known as a "stop". So f/8 lets in one stop more than f/11 and two stops more than f/16. And
4. that there are also "half-stops" which go between the stops – you'll see them on the viewfinder and top-plate

LCD panels. For instance the half-stop between f/5.6 and f/8 is f/6.7, and the half-stop between f/11 and f/16 is f/13.

5. that a given aperture is the same on all lenses. That is, f/8 on a wide-angle lens lets in the same amount of light as on a telephoto lens.

Shutter speeds operate in a similar way. Their series, though, is more obviously logical, running, on the Canon EOS5/A2/E as follows:

1/8000 sec, 1/4000 sec, 1/2000 sec, 1/1000 sec, 1/500 sec, 1/250 sec, 1/125 sec, 1/60 sec, 1/30 sec, 1/15 sec, 1/8 sec, 1/4 sec, 1/2 sec, 1, 2, 4, 8, 15 and 30 seconds. Once again, these are all full stop gaps, with each representing a doubling or halving of the light let through – a shutter speed of 1/30 sec admitting twice as much light as the briefer 1/60 sec. And, once again, when you look on your LCD panels you'll find half-stops: 1/3 sec, 1/6 sec etc.

In most situations there are several ways in which the aperture and shutter speed could be combined to give the same exposure, and choosing the right combination is one of the keys to successful photography.

For instance on a sunny day, with ISO 100 film, the following exposures would all let in the same, right amount of light:

1/60sec	1/125 sec	1/250 sec	1/500sec	1/1000sec
f/16	f/11	f/8	f/5.6	f/4

However the effect would be very different. Without getting too deeply into it, shutter speeds control any movement in the picture, freezing or blurring it, while apertures control depth-of-field, the zone of acceptable

sharpness in front of and behind the point actually focused on. So the 1/60 sec and f/16 option would have a lot more of the picture sharp, although any moving subject would probably blur, while the 1/1000 sec option would freeze any movement but not have the same amount of the scene sharp.

Luckily, because the Canon EOS5/A2/E is blessed with a lot of metering options, you don't need to know any more than that – you can leave the camera to do the rest. It's just that a basic understanding really helps improve your picture-taking.

On the camera you'll find four Creative Exposure Modes and three different metering patterns. In simple terms, it's the job of the metering pattern to get the right amount of light on the film, and the job of the exposure mode to get it on in the right way.

We'll be looking at each of these modes and patterns in later sections, considering what they do, and how to make the most of them.

EXPOSURE
METERING PATTERNS

When I contemplate the exposure system of a camera such as the Canon EOS5/A2/E I find myself thinking about those wonderful black & white films you occasionally see on television that show what computers looked like in the 1950s and 60s.

And I have no doubt, had it been around then, that the state-of-the-art computerised technology that the appliance of microchip science has miniaturised to fit into the Canon EOS5/A2/E would, thirty years ago, probably have filled a room the size of your average lounge.

The rate of technological advance in micro-electronics

over recent years has been astounding, and no more so than in the design of cameras. Just compare the EOS5/A2/E with the first EOS, the 600 (US 630) launched in 1987, and see how much more advanced things have become in just five years.

In fact it's hard to believe that only in recent times cameras have had meters in them at all. Imagine that! Not long ago, before you could get to the point of actually taking a photograph, you had to use a separate hand-held exposure meter to take a light reading and then transfer it to the aperture and shutter speed dials of the camera. Every time the sun went in, or came out, or the light changed in any way whatsoever, you had to take another reading.

It may sound old-fashioned now, quaint even, but it really wasn't a particularly difficult or even time-consuming thing to do, once you'd got the hang of it. And, indeed, a good number of keen amateur and professional photographers still follow exactly the same procedure today.

There was some merit in all this, of course, because you had to understand fully the principles of exposure to even contemplate starting in photography – and having that understanding helped give you the skills needed for taking first-class photographs. Modern photographers, weaned on auto-everything cameras, don't always have that same understanding.

The next stage in the evolution of camera metering was to mount the exposure meter on the outside of the camera, which perhaps made the whole business slightly easier, but not much.

Then came the crucial development, when an exposure meter was sited for the first time inside the camera, in such a way that you were taking readings Through-The-Lens – and what we now know as TTL metering was born.

Those first meters were very simple, and read the whole of the picture-taking area, which meant they could be spectacularly unreliable, and easily influenced by huge areas of sky or other large light or dark areas.

Then centre-weighted metering was developed. This still metered from the whole of the scene, but gave greater emphasis, or weighting, to the central area. After that came partial metering, which concentrated on a relatively small, partial, area in the middle of the viewfinder, and spot metering, which went even tighter, typically focusing in on just 1-2% of the scene.

With the rapid development of micro-electronics came the introduction of so-called "intelligent" meters, which are programmed with a "library" of lighting patterns against which they compare the scene before them.

Which brings us back to the sophisticated 16-zone evaluative metering system found on the Canon EOS5/A2/E – one of the most intelligent systems to be found on any camera available today. Let's find out more about it, and the other two metering options available on the EOS5/A2/E.

EVALUATIVE METERING: WHAT IT DOES, WHEN TO USE IT

If you've ever played chess with a computer, you'll know how hard it is to win. Skilfully programmed, computers can make formidable enemies. Set them up to assist you, though, and they can also make formidable allies.

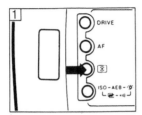
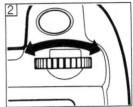

Take the Evaluative Metering system in the Canon
EOS5/A2/E. No wonder they call it an "intelligent" system,
because the processing power it brings to the calculation
of exposure makes exposure errors virtually a thing of the
past.

With its 16-zones, built around the 5 focusing points, the
meter can take account of the subject size, the overall
lighting level, front lighting and back lighting, and – here's
the really clever thing - the focusing point in use. So if
your subject's over to the left, that's where you look, that's
where the camera focuses – and that's where the meter
automatically places its emphasis.

In creating the 16-Zone Evaluative metering system,
Canon analysed thousands of different kinds of
photographs and stored the information so that future
scenes could be compared against it – and exposure
compensation given automatically when required.

The camera also knows when its turned on its side,
thanks to an internal switch, and compensates according.

In all the time I've been using the EOS5/A2/E, the
Evaluative Metering system has proved its ability in even
the most demanding of situations.

CENTRE-WEIGHTED AVERAGE METERING:
WHAT IT DOES, WHEN TO USE IT

Centre-weighted average metering has been the most common form of metering pattern for the past 20 or so years. It meters from the whole of the picture area, but gives, as its name suggests, greater emphasis to the central part of the picture, in the expectation of that being where the main subject is. Pretty accurate and reasonably reliable the system has proved too. It's not being replaced because it's no good, simply because something better has come along.

So the big question you have to ask, in respect of the Canon EOS5/A2/E, is why would anyone use plain-old centre-weighted average metering when 16-Point Evaluative Metering is now available. Or to put it another way: who would drive a Ford if they could have a BMW, and who would eat a hamburger when there was caviar on the menu?

The answer is obvious: someone who likes Fords and hamburgers.

Maybe with your previous cameras you've always used centre-weighted metering. You know what it can do and what it can't; you know when it will fail and what to do about it when it does. So why change? Why not continue using it on the Canon EOS5/A2/E?

That's a valid position to take, and probably the only one which would really justify sticking with the centre-weighted average metering. If you feel that way, then stick with what you feel safe. But some time, when you're out taking pictures that aren't too important, take a small risk and give the Evaluative Metering a go. You won't be disappointed.

SPOT METERING:
WHAT IT DOES, WHEN TO USE IT

In some situations you may want to meter very accurately and precisely, which is why Canon give you the option in the EOS5/A2/E of Spot Metering, which limits the metering area to just 3.5% of the picture.

Before going any further, though, it's worth issuing a warning: do not set the Spot Metering function to see what happens, and then go out and take pictures as you would normally – because a lot of them will come back wrongly exposed.

A chisel or a plane can be a powerful and effective metering tool in the right hands. In the wrong hands it can be dangerous. So it is with Spot Metering. You can't just use it willy-nilly, you need to know what to meter from if you're going to use it successfully.

What should you be metering from? Generally it's your main subject. The principal time you'd want to use the Spot Metering is when the key element in your photograph is set against either a very bright or very dark background, and there's a danger of under- or over-exposure. Then you should use the spot metering function to go in close and take a reading directly from the subject, hold it with the AE-Lock, and then take your shot.

The standard set-up is with spot meter at the centre, but it's possible to move the spot with Custom Function 15, which ties the spot metering in with a manually-selected focusing point.

See example picture on page 53

GREEN RECTANGLE MODE
JUST POINT 'N' SHOOT

We said earlier that Canon have been very clever in producing the EOS5/A2/E. On one hand it's a camera the man in the street could pick up and start taking acceptable pictures with in minutes, yet satisfy the needs of a photographic enthusiast for years. How can that be?

The secret lies in the way Canon has built in layers of complexity. Allowing you to take as much responsibility as you want.

The starting point is the Green Rectangle mode, created principally with the beginner in mind. Set the EOS5/A2/E to the Green Rectangle position on the Command Dial, and you can be assured that everything is being set for you automatically.

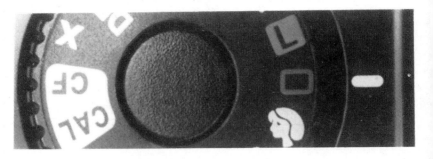

In Green Rectangle mode the camera will:

• use its Evaluative Metering System to assess the scene and set appropriate shutter speed and aperture, taking account of the sensitivity of the film, the focal length of the lens in use, and prevailing light levels
• set the transport system to advance the film one frame at a time

- put the focusing system into One-Shot/AL Servo mode and ready the built-in flashgun to fire automatically as required. (Note: on the North American EOS A2E and A2, the flashgun has to be raised manually).

When you first get the EOS5/A2/E you're likely to welcome the Green Rectangle mode as an excellent way to get started, leaving the camera to work it all out for you while you find your feet and get to know what everything's for. But once you've done that, and you gain in confidence, you'll almost certainly move on to other modes, which you'll probably find serve you better.

For in reality the Green Rectangle mode is a bit of a compromise. It's good at most things, but in truth excellent at nothing – a jack-of-all-trades-and-master of-none.

That said, you may find there are still some situations when the Green Rectangle will come in handy.

There may be times when you simply want to take pictures, not practice photography – so you'll welcome having the EOS5/A2/E set up like a glorified compact.

Or there may be occasions when you want or have to lend the camera to a member of your family or friend who lacks the ability or experience to use it at a more technical level

Perhaps, if you have children, you could encourage them to use it (with care!) and so lead them into the exciting and fascinating world of still photography from an early age. We all have a duty to build the hobby for tomorrow, after all.

IMAGE ZONE MODES
AUTOMATIC SHOOTING MADE EASY

So, while you'll certainly find the Green Rectangle a foolproof way of starting to take successful photographs with the Canon EOS5/A2/E, you'll soon discover its limitations.

The fact is that no single exposure program can tackle every kind of picture-taking situation. Experienced photographers tailor their techniques to the subject in hand, making use of the facilities their camera provides to produce a creative and personal interpretation of the scene, rather than just a simple record of what was there.

Building up the knowledge required to make the right decisions takes time, so Canon have incorporated into the EOS5/A2/E a collection of more specific picture-taking modes they call Image Control Modes. On previous Canon EOS cameras these were called Program Image Control (PIC) Modes, but although the name has changed the principles remain the same – namely a pre-set package of camera functions to maximise the opportunities offered by a range of popular subjects: portraits, landscape, action and close-up.

The great advantage of these modes is that there's no need to worry at all about the technical side of things, all the important decisions, about metering, exposure, focusing, film advance and flash are taken for you – completely automatically - leaving you free to concentrate your attention fully on composing the picture.

This makes them not only applicable to newcomers to photography, but also to more experienced picture-takers who want to be sure of capturing every opportunity.

Setting the Program Image Control Modes is easy:

simply rotate the Command Dial until the mode you want clicks into place against the line. The icons are probably self-explanatory, but to make doubly sure, here's what they mean:

PORTRAIT

LANDSCAPE

CLOSE-UP

SPORTS

AT-A-GLANCE
CANON EOS5/A2/E IMAGE ZONE
EXPOSURE MODES

MODE	Metering	Exposure	Focusing	Film ADV	Flash
Portrait	Evaluative	Large aperture	One-shot	Continuous	Auto
Landscape	Evaluative	Small aperture	One-shot	Single-shot	Off
Sport	Evaluative	Fast shutter speed	AI Servo	Continuous	Off
Close-up	Spot	Small	One-shot	Single-frame	Auto

PORTRAIT AUTOMATIC MODE

People love to take pictures of other people, indeed it's the reason why many buy a camera in the first place. In fact if the government ever passed some crazy edict making it against the law to photograph human beings, you could safely bet your last penny that the great majority of cameras would suddenly lie unused.

Yet far too often our people pictures disappoint. Yes, they offer a reasonable and recognisable likeness, but somehow they fail to go beyond that. What we really want to do is capture their character on film, that indefinable something that makes one person different from another.

To help us achieve that elusive goal, Canon have set up a Portrait mode on the Canon EOS5/A2/E, shown on the Command Dial as a woman's head in a circle. The mode

offers us a package of features that will help you take better people pictures.

The first thing Portrait mode gives us is continuous shooting, up to 3 frames-per-second, allowing us to take a series of pictures one after the other. Why is that useful? Because the human face is a wonderfully mobile thing, across which in the space of just a few seconds can run an incredible range of emotions: first laughing, then curious, then sad, then pensive, then angry then...who knows what?

Catching such fleeting expressions on film is not easy, but is in many ways the secret of successful portrait photography. It requires an alert photographer, with a quick eye and lightning reactions, and a finger always ready on the trigger. When you see the look you want, don't mess about, take several pictures one after the other. When you examine them later you'll notice that they're not all the same: the expression or pose will have changed in some subtle way and, if you're lucky, you'll have found what you were looking for.

If you want your people pictures to have impact, you need to fill the frame with your subject – don't have them standing some distance away, go in close. But there is a right and a wrong way to fill the frame.

The wrong way is to use a standard lens and get physically close to the person, perhaps 3 to 4 feet away. This doesn't work, because you'll be entering their personal comfort and making them feel nervous – which is not likely to produce the kind of expression you're after.

The right way is to use a telephoto lens. For general portraits, such as head & shoulders, a focal length between 80mm and 120mm is ideal, giving you a distance of about 6 to 8 feet: close enough to hold a conversation, not too close to be intimidating. The top end of the Canon EOS5/A2/E's 28-105mm standard lens is perfect for a

wide range of people pictures.

Another useful tip is to watch your backgrounds. There's nothing more annoying than shooting a superb set of portraits only to find them marred by a cluttered and distracting background. Going in closer will help solve the problem, but you also need to remember to look around the edge of the frame before pressing the shutter release, just to make sure there's nothing which will take the viewer's eye away from the person. If there is, move your subject around so the background is as plain and sympathetic as possible.

Luckily the Portrait mode is set up to help minimise the effect of distracting backgrounds by selecting a large aperture such as f/2, f/3.5, f/4, which, because of the way lenses operate, will throw much of what's behind the subject out-of-focus. To help the mode do its work, you need to position your subject as far away from the background as possible – so simply getting them to step a few paces forward can help enormously.

Take care also, when shooting in Portrait mode, to focus very carefully and accurately on the eyes, because if the eyes aren't sharp then the picture will look wrong.

Naturally the camera will automatically sort out all the exposure technicalities for you: this time by selecting its sophisticated Evaluative Metering system and assessing all areas of the scene before making an exposure decision. So in one sense it doesn't really matter what the light's like, you can rely on the camera to make the best of it. But in another sense, the light is very important indeed, and has significant impact on how well the pictures come out.

You might expect that the best light for portraiture would be on a bright, clear, sunny day – but you'd be wrong. The problem is that very strong sunlight casts deep shadows which look unpleasant under the eyes, nose and chin. If

you want to shoot portraits on a bright day, try to find a shaded area, perhaps under a tree, where the light is still strong but less directional. If that's not possible, put the sun behind or to the side of your subject, so they're not squinting into it, and the EOS5/A2/E's built-in flash will automatically pop into action (but not on the A2E and A2) and fire to fill-in the shadows. Make sure that you set red-eye reduction to avoid a ghoulish result. The built-in flashgun is also useful for brightening up portraits and giving them a lift on a dull day.

Overall, though, the best light for portraits is found when there are light clouds covering the sun: you'll get soft, gentle shadows that work wonderfully well.

HINTS & TIPS ON PHOTOGRAPHING PEOPLE

In the section above we've been talking about how to capture someone's character and personality on film by isolating them from the background and concentrating on them as individuals. But there is also another approach: the environmental portrait, where the person is shown in a context or situation that says something about them.

Most of the time you have the choice, and it's a matter of photographic intent and personal preference which you go for. When photographing a construction worker, for instance, you could either opt for a close-up of his weathered, sun-tanned and leathery face (character study) or show him working, tools in hand (environmental portrait).

There's a difference in lens use too. Environmental portraits are often taken at a wide-angle setting, between 28mm and 40mm, allowing both subject and surroundings

to be crammed into the frame. So you can't rely upon the Portrait mode if you want to shoot environmental portraits; choose instead aperture-priority mode from the range of Creative Exposure modes, and set an aperture around f/11.

Getting people to relax when you're taking their photograph is a great skill, and one that is possible, and useful, to develop. The problem is that the instant you point a camera at someone and ask them to say "cheese", they become self-conscious and freeze. It's just human nature. And it never seems to matter how well you know them, it still happens – with wooden expressions and poses as the result.

There are ways and means of getting them to loosen up, of course. You can chat to them, share gossip, tell a joke – in fact anything that helps them to forget about the camera and become less self-conscious. However, at the end of the day, you have to come to terms with the fact that there are a lot of people who do not like having their picture taken.

One option around this is to have a go at shooting some "candids", with them unaware of the fact that they're being photographed. If they don't know you're pointing a camera at them, they're not putting on any kind of act, giving you the best chance of capturing them at their most natural. Here it's best to use a longer length lens if you have one, a zoom covering the range 100-300mm would be ideal. Once again, the portrait mode would be inappropriate – but, because the approach has much in common with sports photography, the Sports mode would work just fine. A good example is my picture on page 54.

LANDSCAPE AUTOMATIC MODE

After portraits, it's landscapes that are the most popular subject for photography. So Canon have provided a mode specially set up to tackle scenic photography, shown on the top-plate Command Dial as hills with a cloud.

The first thing to say is that there's no hurry when you're taking landscapes. After all, they're not going to get bored and go off and do something else. They've got time on their hands, and they're only too happy to hang around and pose for as long as you want. So naturally the camera sets One Shot focusing and single frame advance, letting you take one picture at a time. No rush, nice and easy: that's the essence of landscape photography.

True, you can sometimes get a more dynamic, faster-changing situation – on a blustery day, with clouds scudding dramatically across the sky, or late in the evening with the light changing rapidly, but One Shot focusing and single frame advance will still cope very nicely thank you.

The most popular way of approaching landscape photography is to use a wide-angle lens together with a small aperture, such as f/11 or f/16, to get a from-here-to-infinity sharpness – and that coincides with how the Canon EOS5/A2/E's landscape mode is set up.

Precisely what lens you use is entirely a matter of choice. Not long ago 28mm was considered by most photographers to be best, and if you have one, or a 28mm setting on a standard zoom, then you'll find it works very

effectively. If you have a standard zoom starting at 35mm, by all means give it a go, and you should be able to achieve some excellent results.

Increasingly, though, wider angled lenses are coming into favour for landscape photography, with 24mm considered the minimum necessary now, and others preferring to go as wide as 20mm. Used carefully, these lenses give a very dramatic perspective – used badly, they produce pictures with little or no impact.

The secret lies in having something of interest in the foreground of the scene, as well as in the middle and background. This gives a sweeping sense of depth, which is why it's important to have a small aperture, so that everything can be kept in focus from front to back.

Be aware, though, that if the camera sets a small aperture it will also be setting a relatively slow shutter speed – which is why so many landscape photographers anchor their cameras firmly to a tripod. Some also use them to help deliberately slow down their picture-taking, which is where we came into this section...

The flash, not surprisingly, is switched off in this mode. Landscapes, by their very nature, tend to be a long way off, and it would be futile, to say the least, to try to brighten up Stonehenge or the Grand Canyon with the flashgun built into your EOS5/A2/E – a bit like those poor misguided optimists you see popping a flashcube two miles back at a Michael Jackson concert.

My picture on page 123 gives good foreground interest, for which I used a 28mm lens.

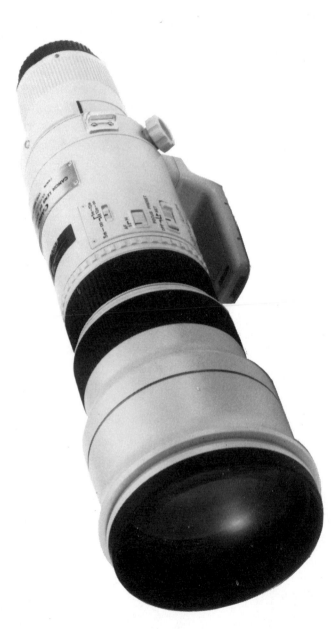

CANON LENS EF 500mm 1:4.5L (ULTRASONIC)

LANDSCAPE HINTS & TIPS

Most photographers, as we've already said, when squaring up to their favourite landscape will automatically reach into their bag for a wide-angle lens. Well it makes sense, doesn't it? Landscapes are big – aren't they? – so you obviously need a wide-angle lens to cram it all in.

Well, not always. Sometimes you can create a more impactful landscape image by using a telephoto lens to pick out interesting details in the distance. A zoom lens in particular, such as the Canon EF 75-300mm or EF 100-300mm, is perfect for cropping the shot precisely how you want it. Be aware, though, that when approaching landscape in this way you should not use the EOS5/A2/E's Landscape mode. It won't give you the effect you're after. Choose instead Aperture-priority from the range of Creative Exposure Modes on offer.

One other thing worth mentioning while we're talking about landscape is how important light is to the subject. Generally – and there are exceptions – landscapes need strong sunlight to bring them to life. But if you can, avoid the middle of the day, when the sun is high, creating high contrast and few shadows. Save your film, take a siesta or have a beer, and come back later, around dusk, when the light is low, skimming across the surface of the Earth and throwing long and highly photogenic shadows.

SPORTS AUTOMATIC MODE

You may have seen professional sports photographers on the television, with their huge lenses, as long as your arm and with front elements as big as a dinner plate, and thought that sports photography was way out of your

league. If you're talking major events like the Cup Final or the Open, then you're probably right. Remember, though, that there are lots of smaller, more local events that offer the same big-game thrills but which are a whole lot more accessible. So why not give it a go? True, it's not as easy as portraiture or landscape photography, but who wants always to take the easy option? Sports photography is more challenging, and because of that you'll learn new skills and new techniques which will greatly improve your picture-taking. Besides, with just a little practise you'll find that shooting sport isn't that hard after all. Just different.

To get into sports you need to start by setting the Sports mode on the Command Dial, represented by an icon of a sprinter at the bottom of the dial. As with other modes, this gives you a pre-set package of functions suitable for tackling sport successfully.

Sport, almost by definition, is about movement, and in many sports the movement is extremely fast, so the first thing you get, not surprisingly, is fast shutter speeds capable of freezing the action. For most situations 1/500 sec is the minimum necessary, and in some sports where there is sudden, explosive action, speeds of 1/2000 sec and 1/4000 sec may be necessary – well within the capability of the EOS5/A2/E which goes right up to 1/8000 sec.

At most sports events the subject is some considerable way off, and long focal length lenses – 400mm and 600mm are the most common among professionals – are

required to fill the frame with the action. Such long lenses need at least 1/500 sec without support for you to be confident of getting a sharp picture – so the fast shutter speeds set by the Sports mode also help protect against camera-shake.

If the shutter speeds are fast then the apertures will obviously be large, giving limited depth-of-field and a small zone of sharp focus. This is no problem, providing the focusing is accurate, as it should be on the EOS5/A2/E, with its AI Servo focusing mode. The camera's sophisticated Predictive AF system can track a moving subject, assess its speed and direction, and anticipate its future movement – thus predicting where the subject will be when the shutter opens and the lens focuses. All this happens in a fraction of a second, with pin-sharp pictures as the result.

To back this up, the Sports mode of the EOS5/A2/E also sets Continuous High-speed film advance. In theory this operates at up to 5 frames-per-second, but, because of the AI Servo focusing system, 3 frames-per-second is the practical limit.

In any fast-changing situation accurate light metering is essential. The Sports mode dials in the camera's 16-zone Evaluative Metering system. Sport can throw up some immensely tricky exposure situations, such as a dark-clothed skier against snow, or a sun-lit person in front of a deeply-shaded background. In all these situations the Evaluative Metering system compares the scene to its huge library of lighting situations and makes a judgement based on that. Once again, amazingly, in less time than it takes to blink an eye.

Finally, and obviously, the built-in flashgun is switched off.

SPORTS HINTS & TIPS

The skills needed to be a successful sports photographer are similar to those needed to be a successful sportsman: lightning reactions and constant readiness. It also helps considerably if you know the sport you're photographing – then you can anticipate how the action is going to develop, and when and where the best pictures are going to be taken.

As we said earlier, when starting sport it's a good idea not to set your sights too high. Start small, start local, build your skills, and then look to tackle national events.

Remember, too, that although this is called a "Sports" mode, it can be used to tackle any kind of action photography, from running horses to your children turning cartwheels. Don't be hidebound by definitions.

Nor do you need to feel impeded by lack of equipment. If your only lens is a 28-105mm, fine. Learn to work within its limits – find a sport where you can get close to the action. If you can get hold of a telephoto zoom, one that goes up to 200mm or preferably 300mm, then you have all you need for first-class sports photography.

To make sure the camera is able to set fast enough shutter speeds to freeze the action, especially on dull days or under floodlighting, load up with fast film. ISO 400 is a good, general speed sports film, but if light levels are really dire you may need to go to ISO 800/1000 or even 1600. But be aware that every time you go up in speed you're sacrificing a little quality.

A final thought. Freezing with a fast shutter speed is only one way of capturing action – another option is to use a long shutter speed to produce a blurred, more impressionistic interpretation of the subject. Give it a try. You'll have to move away from the Sports mode, though, and try the shutter-priority mode in the Creative Exposure Modes.

CLOSE-UP AUTOMATIC MODE

Given that the other three Image Zone Modes take in some of the "big themes" of photography you might be surprised to find that the fourth and last is shooting Close-ups. Why on Earth have a special mode for that? But such a view underestimates the superb images you can shoot if you cut away from the wider picture for a while and start thinking small.

Close-up photography opens up a whole new world of picture-taking, and once you get tuned in to working in this way you'll never find yourself short of interesting close-ups to take. Wherever you are, whatever you're doing, potential subjects will be all around you. All you have to do is select the Close-up mode on the Command Dial, symbolised by a tulip, and you're ready to roll.

The first thing to say is that the lens you use to shoot close-ups is obviously important. But, contrary to common belief, you don't need a specialist macro lens – although it would certainly help if you did have one. In practice, all that's required is a lens that will let you crop in tightly, to take in an area that's, say, the size of two pages of this book. And most Canon EF standard and standard zooms will do that. Some telephoto zooms have a close-focusing facility too.

One of the big problems of close-up photography is that you get closer to your subject so it becomes increasingly

difficult to keep everything in focus. With that in mind, the Canon EOS5/A2/E's Close-up mode selects a small aperture, to maximise depth-of-field and keep as much of the scene as sharp as possible. As ever, small apertures can lead to slow shutter speeds, and you're strongly advised to consider using a tripod or other support if the light levels are low.

If they drop too low the camera's built-in flashgun will pop up automatically (but not on the EOS A2E and E). This can be a mixed blessing, as side lighting is often better for bringing out the pattern and texture of close-ups, with frontal light giving a flatter, more two-dimensional result. So if you have the option, move your subject to better light and avoid using the flash.

In other modes it's Evaluative Metering that's set, but in Close-up mode the camera goes for Partial Metering, which means it concentrates on the central area, ignoring the surroundings.

The focusing is set to One Shot, and the film advances one frame at a time, since there's little high-speed action in close-up photography – unless you count butterflies, which are notoriously difficult to photograph well.

CLOSE–UP HINTS & TIPS

The secret of successful close-up photography is to change your way of looking at the world. Narrow your field of vision, pay attention to details. Anything with a strong texture or pattern to it will probably make a good close-up shot.

Another way of working is to set up the subject yourself, as a still-life. If you went to the beach, for instance you could collect shells, sand, seaweed, and combine them in an effective close-up. Similarly a walk in the woods would

yield leaves and bark and stones. Nip out to your garage or workshop: how about some close-ups of tools or whatever else you might find.

Close-up photography is, literally, a whole new world of photography, and the only limit is your mind.

SUMMARY

The four Image Zone Modes have much to offer photographers of all abilities. But once you've got to know them, and have mastered them, it's likely that you'll want to go on to use the Creative Exposure Modes a lot more – although there will certainly be times, as with the Full Auto Green Rectangle mode, when you'll want to return and make use of them.

CREATIVE EXPOSURE MODES
DOING IT FOR YOURSELF

Image Zone Modes are like package holidays: because everything is organised for you, they're safe, secure ways of getting to strange and unfamiliar places – in this case the many and sometimes mysterious worlds of photography.

But when you reach a certain stage in travelling you don't want to be held by the hand any more, you want to go your own way, do your own thing. Okay, so you may make some mistakes along the way, but that can be a good thing, because you learn, and you grow.

So it is with photography. Sooner or later you'll start looking beyond the pre-set Image Zone Mode packages and start wanting to take more control yourself, and start

thinking about turning the Command Dial the other way, towards the Creative Image Modes. Doing so will mark a turning point in your picture-taking, as you start to make more things happen yourself, rather than relying on the camera to do it for you. And your photography will improve because of it.

Of course not so long ago, before Image Zone Modes and Program Image Control modes were invented, Creative Exposure Modes were all we had, which forced us at a much earlier stage to understand some of the principles of photography. The positive side of that is obvious – people got into the creative side of picture-taking sooner. The negative side was that some didn't make it, put off by all the technicalities.

But now cameras such as the Canon EOS5/A2/E offer more of a progression. You don't start by abseiling from a height of 200ft blindfold. You build your confidence and skill by doing it with your eyes wide open from 40ft first. So start with Image Zone Control, and when you feel ready, make the move to Creative Exposure Modes.

FIVE MODES TO CHOOSE FROM

The EOS5/A2/E offers a choice of five Creative Exposure Modes. Why so many? Well, once again, it's all about giving the photographer choice: different subjects require different treatment, and different people have different ways of working.

If you're a new photographer you'll have an open mind and be willing to try any and probably all of the modes on offer. But if you're an experienced photographer you may well have established ways of working which you'd prefer to continue with.

I, for instance, have spent many years using cameras in

aperture-priority mode, so I still tend to, even when there are other options available to me. I feel comfortable and in control if I choose the aperture first, and that's the way I take my best pictures.

Some of you will almost certainly be long-time Canon users, and will have owned, and may still do, Canon's excellent AE-1 and AE-1 Program cameras from the 1980s. These were unusual at the time in that they were based around a shutter-priority mode, and you may have formed the habit of selecting the shutter first and prefer to keep working that way.

At the end of the day, it really doesn't matter at all. The key thing is getting the right amount of light on the film, and all of these modes do that, and do it very well. You now have the luxury of choosing which fits your way of working best, and that can only be a good thing.

The important thing to remember, though, is that getting the right amount of light on the film isn't enough. It's how you do it, what the specific combination of aperture and shutter speed is, that produces the creative effect you're after.

PROGRAM (P) MODE – WHAT IT DOES

Program Mode is the most automated of the Creative Exposure Modes, setting both aperture and shutter speed automatically for you.

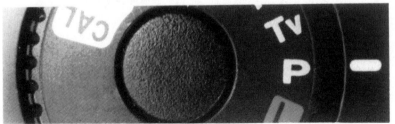

Because in the EOS system the camera and the lens are interactive, that is they "talk" to each other, the camera is well informed when it comes to making decisions. At any time it "knows" what the focal length of the lens is, and, if it's a zoom, the position at which it is set; the point the lens is focused on; and the maximum and minimum aperture.

Of these it's the first, the focal length of the lens, which is most important because one of the Program Mode's priorities is setting a shutter speed fast enough to reduce the danger of camera-shake. So with a 50mm lens the Program mode would try to set a shutter speed of 1/60 sec or faster; with a 200mm lens it would be 1/250 sec or faster. Having done that, it will go for a middle-of-the-road exposure balance: favouring neither small nor large apertures, fast nor slow shutter speeds.

However, at any point you can over-ride the combination of aperture and shutter speed which the camera has chosen, simply by rotating the Main Input Dial. As you do so you'll see in the viewfinder display and on the the top-plate LCD the shutter speed and aperture change – but of course the exposure level itself will remain the same.

Arguably, then, you need never switch out of Program, since with a quick spin of the Main Input Dial you can vary the aperture/shutter speed combination without altering the exposure level at all.

PROGRAM (P) MODE – WHEN TO USE IT

Program Mode can be relied upon a lot of the time, and many photographers do. It's ideal for general picture-taking where there's nothing you particularly want to achieve creatively.

However, like the Full Auto Green Rectangle mode, it

can be a bit of a compromise, producing pictures that are a little bit bland. You might like to try either the aperture- or shutter-priority modes to see if they fit your photography better. It's amazing what a change of approach can do. Thinking in different ways might result in you taking different pictures.

APERTURE-PRIORITY (Av) MODE – WHAT IT DOES

Aperture-priority mode lets you choose the aperture and sets a corresponding shutter speed to give correct exposure. The importance of the aperture is that it controls the "depth-of-field" in the picture.

Depth-of-field is a concept which many photographers half-understand and which makes the eyes of others glaze over in terror. But the principle is pretty simple. Depth-of-field is the size of the zone of sharpness in front of and behind the point you actually focus on which will appear sharp in the finished picture.

Setting a small aperture (big number), such as f/11, f/16, f/22, gives lots of depth-of-field – that is, there will be a deep zone of sharpness.

Setting a large aperture (small number), such as f/1.8, f/2.8, f/4, will give limited depth-of-field – that is there will be a very narrow depth-of-field.

Many photographers think in terms of depth-of-field, and the question they ask themselves before starting to take pictures is, "do I want lots of depth-of-field or just a little", and then they set the aperture accordingly.

At the same time some consideration has to be taken of the shutter speed, to ensure that setting a small aperture won't result in a long, camera-shake-inducing shutter speed.

APERTURE-PRIORITY (Av) MODE – WHEN TO USE IT

It probably goes without saying that the time to use aperture-priority is when the aperture is important – but when is that? Generally it's in situations where you either want extensive depth-of-field, to get as much of the picture sharp as possible, or where you want limited depth-of-field, to restrict the zone of focus.

For a more detailed discussion of depth-of-field, check out the section on the Depth Mode on page 113.

SHUTTER-PRIORITY (Tv) MODE – WHAT IT DOES

Shutter-priority lets you choose the shutter speed and sets a corresponding aperture to give correct exposure. On the EOS5/A2/E you have a wide range of shutter speeds, from 1/8000 sec to 30 seconds in half-stop stages.

The "Tv" Mode heading stands for Time Value .

SHUTTER-PRIORITY (Tv) MODE – WHEN TO USE IT

The obvious time to use shutter-priority is when the shutter speed is more important than the aperture. The times when this will be the case are when you want to stop action or blur it, or defend against camera-shake.

Learning what shutter speed to use for action is largely a matter of experience. At first, if you want to freeze action, you should go for the fastest shutter speed circumstances will allow, and then experiment with slightly longer speeds. Using longer shutter speeds to blur action

is less clear cut, because there is always a matter of judgement about what is successful and what is not. It all depends on how fast the subject is moving, and where you are in relation to it. Generally it's best to pan along with the subject, that is, follow it with your camera and lens as it moves across you, firing the shutter at the same time. "Panning" like this will hopefully give you a subject that is predominantly sharp against a blurred background. Try shutter speeds of 1/15 sec, 1/30 sec and 1/60 sec to start with.

MANUAL (M) MODE - WHAT IT DOES

In manual mode you set both shutter speed and aperture yourself, guided by a display in the viewfinder and on the top-plate. This sounds good, but do be aware that it can be a doubled-edge sword that can cut both ways.

The up-side is that you have complete creative control over exposure. The down-side is that it's a whole lot easier to make mistakes. Serious ones. Get your exposure wrong and it'll be like the bad old days - your picture won't come out. Let me say this, as someone who has spent many years using cameras with manual exposure systems: you might, if you're really skilful, sometimes take a better picture in manual mode. Basically I'm a convert to technology. With sophisticated metering systems such as those in the Canon EOS5/A2/E you really don't need manual metering any more.

But enjoy playing with it if you want. When you switch to it, you'll see the exposure compensation dial in the two displays change, what it will give you is an indication of how much the camera believes you'll over- or under-expose at present settings.

MANUAL (M) MODE –
WHEN TO USE IT

My advice would be to stay away from Manual mode until you're very experienced and fully understand the principles of exposure. Situations in which you may then want to switch to Manual are when you want to dabble in the Zone system or if you need to copy some old pictures or other flat artwork.

BULB SETTING –
WHAT IT DOES

The Bulb setting is accessed by turning the Command Dial to M and then turning the Main Input Dial past 30 seconds until the word "bulb" appears in the LCD panel. Bulb lets you open the shutter for as long as you want to achieve a range of creative effects.

BULB SETTING –
WHEN TO USE IT

The only time you would want to use the bulb setting is when you need an exposure that's longer than 30 seconds – if it's up to 30 seconds then it makes sense to use one of the other modes. The kind of thing you might use it for are night exposures, streaking the trails of moving cars, and photographing fireworks. In situations such as that, make sure the camera is firmly anchored to a tripod, set a small aperture, and fire the shutter with a remote release.

DEPTH MODE –
WHAT IT DOES

The Depth Mode selects the best aperture to keep the depth-of-field within a designated zone-of-focus. To set it, you move the Command Dial to the Dep position, aim the camera at the nearest point you want to appear in focus and press the shutter release half-way. Then aim the camera at the farthest point and press the shutter release half-way again. You then re-compose the image in the viewfinder and press the shutter release all the way. The camera automatically chooses the lens aperture needed to give the depth-of-field required to keep the nearest and farthest points acceptably sharp

DEPTH MODE –
WHEN TO USE IT

The most obvious use of the Depth Mode is to maximise depth-of-field, as in landscape photography, where you may want to get everything from a few feet in front of the camera right through to infinity in focus. A less obvious application would be to minimise the depth-of-field. If, for instance, you're taking a picture of someone, and you want them to be sharp but the background as much out-of-focus as possible, your nearest point might be the tip of the nose and your farthest point the ear.

EXPOSURE COMPENSATION
FINE-TUNING EXPOSURE

No automated exposure system, however good, is ever 100% accurate. So the Canon EOS5/A2/E offers you a

number of ways of fine-tuning your exposure to increase your success rate.

But before we go further into this, we need to ask an interesting and pertinent question: if Evaluative Metering really is as good as Canon says it is, why do we need exposure compensation?

And the answer is: increasingly we don't. Having now taken several thousands of pictures on the Canon EOS5/A2/E, in just about every kind of lighting situations you could think of, I'm pleased to say that I've suffered very few failures. Most of the time I've relied completely on the camera's Evaluative Metering, and the vast majority of the time my faith in it has been rewarded with accurate exposure.

To be perfectly honest, if you only ever shoot print film, which has tremendous exposure latitude, you could probably afford to skip this chapter as it's unlikely that the camera will ever fail you. That said, of course, it's useful to understand fully all the camera's features and what they can do for you. If you shoot slide film, though, or expect to, then you should certainly continue reading.

The key to understanding when you might need to give exposure compensation depends upon being able to recognise the "tricky" situations in which exposure meters are prone the failure. Here's a list to watch out for:

8 SITUATIONS WHEN YOU MIGHT NEED TO GIVE EXPOSURE COMPENSATION

1. When the background is very light, such as sand, sea, snow or a white wall. This can cause the meter to under-expose, and render your main subject too dark.

Solution: increase exposure by around 1 to1/2 stops.

2. When the background is very dark, such as a sunlit figure in front of deep shadow or a spot-lit performer on stage. The meter may over-expose, "burning out" your main subject and making the background muddy. Solution: Reduce exposure by approximately two stops.

3. When there is a light source in the picture, the meter can think that the scene is brighter than it really is, and so under-expose. Solution: increase exposure by between 1 to 2 stops.

4. When there's a lot of sky in the picture, the meter may under-expose, especially if you turn the camera on its side. Solution: Take an AE-Lock reading from the ground excluding the sky.

5. When you're shooting into-the-light, if you accept the meter reading you may end up with under-exposure. Solution: increase exposure by about 2 stops.

6. When your subject is standing in front of a window, the effect is the same as shooting into the light, and the solution the same: increase exposure by about 2 stops.

7. When your subject is very dark, the meter will assume that there's a range of tones and therefore increase exposure, making your subject come out grey. Solution: reduce exposure by between 1 to 2 stops.

8. When your subject is very light, under-exposure will result. Solution: typically 2 stops additional exposure will put things right.

USING THE AE-LOCK BUTTON

The secret of exposure accuracy lies in exposing for the subject, not the whole scene. Which is why the Canon EOS 5A2/E's AE-Lock button is so useful: it lets you choose the area from which you want to meter. All you have to do, is go in close to the subject, take a reading, press in the AE-Lock button to hold onto it, return to your original picture-taking position, compose, and take your shot. You're virtually guaranteed an accurate exposure.

USING THE EXPOSURE-COMPENSATION SYSTEM

The Canon EOS5/A2/E has a superbly-designed exposure compensation that very easy to operate. Simply engage the over-sized Quick Control Dial on the camera

back by turning the switch above it to the "I" position, and you're ready. Rotate it clock-wise and you increase exposure, anti-clock-wise and you decrease it. The degree of exposure correction is shown clearly in the top-plate LCD panel and in the viewfinder LCD. The camera allows you to increase or decrease exposure by up to 2 stops, in half-stop increments.

AUTO-EXPOSURE-BRACKETING

There's one other way of ensuring that you get at least one perfectly-exposed shot, and that is to use the camera's Auto-Exposure-Bracketing system (AEB)

"Bracketing" is something professional photographers often do, and it involves taking a series of pictures at exposure settings above and below those that are believed to be correct. This is principally a matter of insurance: if you've spent huge sums of money setting up a shoot in an exotic location, it would be stupid to have to go back and do it all again just because you got the exposure wrong

The AEB system on the Canon EOS5/A2/E takes three pictures of the scene, one at the exposure level it thinks is correct, one with more exposure, and one with less. The degree of over- and under-exposure is up to you. This you set by pressing in the bottom of the four buttons on the camera back until the AEB display is shown, then turning the Main Input Dial. Each turn to the right widens the bracketing gap by another half-stop.

When would you want to use the AEB system? When you're 1) faced with an absolutely unrepeatable picture 2) the lighting is really tricky, and 3) you're just not 100% sure the camera's going to get it right.

It's also worth remembering that bracketing is really only worthwhile with slide film, which is more demanding of exposure accuracy than print film. Whereas most print films will now give acceptable results if they're over-exposed by up to five stops or under-exposed by up to two stops. Even half a stop variation in exposure can ruin slide film.

When bracketing slide film, the size of brackets I would most commonly use would be 1 stop either way.

Warning: Auto-Exposure-Bracketing eats through film like it's going out of fashion. So think carefully about when you want to use it. Don't start using it every time you take a picture. The time to use it is on those special, once-in-a-lifetime situations where the picture's just got to come out.

FILM LOADING & TRANSPORT

Canon have a wonderful way of describing the film transport system on the Canon EOS5/A2/E – they say it's "whisper-quiet".

Now if you haven't used the camera you might be inclined to dismiss it as just another piece of advertising hype, but once you've loaded a film and fired off a frame or two you've got to agree that it's true. So how did Canon manage to make the Canon EOS5/A2/E so quiet?

There are a number of ways:

- Other cameras have sprockets, which engage with perforations along the edges of the film, to ensure that the film moves forward the correct distance, and inevitably this creates noise. The Canon EOS5/A2/E, on the other hand, has a sprocketless optical detection system, which bounces an infra-red beam off the film and counts the sprocket holes as they pass. The good news is that it's completely noiseless. The bad news is that because of it you can't use infra-red film in the camera.

- On most cameras, film wind and rewind is via a noisy gear chain. On the EOS5/A2/E this has been replaced by an almost-silent belt drive system.

- Coreless motors, which produce minimal noise and

reduced vibration have been introduced in place of standard types.

- Extensive use has been made of acrylic and foam to isolate vibrations

The end result of all this "silent technology", as Canon like to call it, is a camera that's so quiet in use that it rarely draws attention to itself.

LOADING A FILM

Loading a film into the Canon EOS5/A2/E is a quick and easy job. You just open the camera back by means of the catch on the left-hand side, drop your cassette in, upside down, pull the film leader across until it reaches the orange mark, then close the back again. The whole job from start to finish takes less than 10 seconds.

Of course it goes without saying, that when you load a film into your camera you have to do it properly. Fluff it, and you kiss goodbye to 36 lovingly-taken pictures. But messing up your film loading is something you don't have to worry about on the EOS5/A2/E – it's impossible to get wrong.

Once you've closed the camera back, film automatically winds on to the first frame, the film counter shows 1, and an icon that looks like a film cassette viewed from above appears on the LCD panel. If the film cassette icon blinks at you, then you know you've mis-loaded – and need to do it again.

Unless you've set Custom Function 3 (see later section), the Canon EOS5/A2/E will automatically set the film speed for you, reading it directly from the film, via the internationally-agreed DX-coding system. If you're the

careful sort, and want to check that it's right, simply press in the multi-function button on the bottom of the row of the camera back until the film speed shows.

If, for any reason, you want to over-ride what the camera's set, then all you have to do is rotate the Main Input Dial until the film speed you want is displayed in the top-plate LCD. Wait for a few seconds and the display will revert to normal, and your alteration will be set. Be aware, though, that any change to the film speed only applies to that film. Remember your next film in the camera will revert to the DX system, and read the speed from the film once again. If you want to over-ride you have to do it again.

FILM REWIND

At the end of a film the camera automatically rewinds. Standard rewind speed is about 20 seconds, depending on the power of your battery. But, if you prefer, you can program the camera to rewind in less than half that time by setting Custom Function 1 (see later section). However the price you pay is a slightly higher noise level – although this can be welcome, as in the standard Whisper Quiet rewind mode it's sometimes hard to hear the film being rewound, especially if there's a lot of background noise.

What you see on the LCD top-plate as you rewind is confirmation: a bit like winning the jackpot on a slot machine in Las Vegas (except you don't get all the other punters coming up to you and wanting to touch you and take some of your luck!). The Eye-Control indicators whizz from right to left while the exposure counts down as if preparing the lift-off of yet another Space Shuttle.

20mm Lens. "Dry Land".

Photo Steve Bavister

24mm. "Archway".

Photo Steve Bavister

28mm Lens. "Giving Foreground Interest".
Photo Steve Bavister

28mm. "Soho".

Photo Steve Bavister

35mm Lens. "Snow Scene".

Photo Steve Bavister

50mm Standard Lens. "Atkinson".

Photo Steve Bavister

35/135mm Zoom Lens. "Cologne".

Photo Steve Bavister

70/200mm Zoom lens. "Jet Ski".

Photo Steve Bavister

200mm lens. "Windsurfer".

Photo Steve Bavister

300mm Lens. "Great Grandpa".

Photo Steve Bavister

REMOVING PART-USED FILMS

At any time you can remove a part-used film, simply by pressing in the small, recessed, black button on the right-hand side of the camera. If you want to leave the leader out, as you probably will if you want to re-load the film later, you should first remember to set Custom Function 2 (see later section).

THREE FILM ADVANCE OPTIONS:

On the Canon EOS5/A2/E you have three film advance options: Single Shot, Continuous advance, and High-Speed Advance, offering film up to 1, 3 and 5 frames-per-second respectively. Let's consider each in turn.

SINGLE SHOT –
WHAT IT DOES, WHEN TO USE IT

As the name suggests, this film advance mode allows you to take just one shot at a time, and for everyday picture-taking it's a good option. The advantage is that you can't fire the shutter by accident, so you don't waste film. The disadvantage is that you have to lift your finger from the shutter release and press it down again to shoot a second picture.

CONTINUOUS ADVANCE –
WHAT IT DOES, WHEN TO USE IT

Once again the name says it all. For as long as you hold your finger on the shutter release the camera keeps taking

pictures, at up to 3 frames-per-second.

This makes this mode ideal for just about any kind of action; for fast-moving situations where being ready for the next shot can mean the difference between capturing the moment or not; and for capturing fleeting expression in portraiture. The good thing about Continuous Advance is that you're always ready for the unexpected.

The only thought to bear in mind is that while it's always exciting to hear a motor-drive eating through the exposures, there's a danger that you might get carried away and burn up film unnecessarily.

HIGH-SPEED ADVANCE – WHAT IT DOES, WHEN TO USE IT

For a camera the size and weight of the Canon EOS5/A2/E to house a transport system capable of banging the film through at 5 frames-per-second is nothing short of remarkable. Not long ago to hit that kind of speed required a big and bulky power pack containing 12 AA-type batteries – now they can do it with just one 6-volt job. Amazing!

For most of us the High-Speed Advance is a feature that's nice to have on the camera, but in reality one which we'll rarely, if ever, use. 5 frames-a-second is one heck of rate, and will see that your film's finished in just under 7 seconds. It's only really justified for high-speed sport such as motor racing, sprinting and skiing.

If you're using AI Servo focusing mode bear in mind that it can only work predictively at up to 3 frames-per-second. So if you really do need the 5 frames-per-second you'll have to switch to manual focusing.

BUILT-IN FLASH
EXTRA LIGHT AT YOUR FINGERTIPS

How many times have you been out taking pictures only to discover that you need a flashgun – and you left it at home to save on weight in your bag. Well with the Canon EOS5/A2/E you'll have no such problem, because built into the top of the camera is an extremely versatile and surprisingly powerful little gun that's always there when you need it.

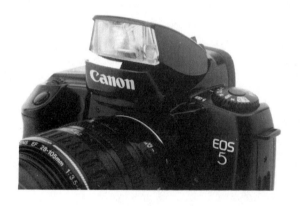

It has an auto zoom mechanism, which adjusts its angle-of-coverage according to the focal length of the lens in use, and has three positions: 28mm, 50mm, and 80mm, which cover the range of most standard zooms, including the 28-105mm which was specially designed with a narrow barrel to avoid blocking the built-in flash. (See DOs and DON'Ts panel below for more info on which EF lenses are and aren't compatible).

As the tube zooms, so the Guide Number varies, rising from 13 at a 28mm setting and 17 at 80mm (m/ISO 100).

The precise distance that the gun can cover depends on a number of factors, including what film is loaded and the maximum aperture of the lens in use. With a 28-105mm lens and ISO 100 film the range would be up to about 4m – swapping to ISO 400 film would double the range to 8m.

The exposure you get from the gun is extremely accurate, because as with the more sophisticated accessory Speedlite 430EZ, the light from the flashgun is read directly from the film by a sensor inside the camera, which then shuts off the output from the flash-tube as soon as enough light has hit the film.

If for any reason you want to reduce or increase the output from the flashgun you can do so by pressing the flash button again, which brings into play a clever flash compensation system operated by the Main Input Dial and displayed on top-plate and viewfinder LCDs.

FLASH DIFFERENCES BETWEEN THE EOS 5 AND THE A2E AND A2.

At this point it's worth mentioning that there is a small but significant difference between the Canon EOS 5 and the North American A2 and A2E models.

CANON EOS 5

The flashgun is fully automatic in the Full Auto Green Rectangle mode and in two of the Image Zone modes: Portrait and Close-up. In low-light or backlight, the flashgun pops up of its own accord, fires, and then pops back down.

The built-in flashgun is activated manually in all of the Creative Zone modes. You simply have to press down on

the Flash Button, which is to the left of the flashgun on the top-plate, and it will fire each time a picture is taken, irrespective of lighting conditions. When you've finished using it you simply put light pressure on the top and push it back down.

CANON A2 AND A2E

The flashgun fitted to the North American specification Canon A2 and A2E models is the same in all respects but one: the gun must be activated manually on every occasion. It will not pop up automatically in the Green Rectangle, Portrait and Close-up modes as it does on the Canon EOS5.

BUILT-IN FLASHGUN – PROS AND CONS

The good thing about the built-in flashgun is its convenience: it's ready, willing and able when you need it. But it does have its drawbacks. The main one is that the top of the camera is probably the worst place to site a flashgun, since it gives a very flat, uninteresting light, with very little modelling. It can also throw ugly shadows behind people, especially if they're standing close to a wall.

In fact, the best place to use the gun is not indoors at all, but outside. Whether it's bright or dull, it's surprising how effective a burst of flashlight can be in improving pictures of people.

On a sunny day, put the sun behind the subject and use the Portrait mode. This will give a well-lit face and hopefully a halo of light around the hair. On a dull day, use the flash in any mode to help lift the colours in the picture.

SETTING THE RED-EYE REDUCTION FACILITY

With the flashgun so close to the lens, there's a serious danger that any people in the pictures will suffer from the dreaded red-eye (where the flash light is reflected back from the blood vessels at the back of the eye, making them glow red). To avoid this unwanted effect, you should select the red-eye reduction system with the bottom button on the camera back. Keep pressing it in until an eye icon appears on the top-plate LCD, then turn the Main Input Dial until a 1 appears. Wait a few seconds, and the system will be set. Then a small light will shine briefly into your subject's eyes before the flash picture is taken, causing the pupil to close down and so avoid their eyes turning red. In practice it works very effectively.

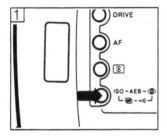 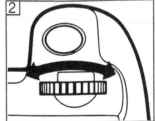

BUILT-IN FLASHGUN DOs & DON'Ts

- Don't use lenses with a focal length wider than 28mm, which is the maximum angle-of-coverage of the built-in flash. If you go wider, the corners of your pictures will be dark.

- Do be careful when using some specialist and fast-aperture lenses. Some of them are physically large, either in length or size of front element (or both) and block out some or all of the light from the built-in flashgun. They should therefore be avoided. These include: EF 20-35mm f/2.8L, EF 28-80mm f/2.8L, EF 80-200mm f/2.8L, EF 50-200mm f/3.5-4.5, EF 50-200mm f/3.5-4.5, EF 200mm f/1.8L, EF 300mm f/2.8L and EF 600 f/4L.

- Don't use lens hoods as they too can get in the way. If fitted, remember to remove them before using the flash.

- Do make sure you remove the plastic hot-shoe cover – with it in place the built-in flashgun won't fire.

EZ-SERIES FLASHGUNS
WHEN YOU NEED MORE POWER

The built-in flashgun is good for everyday picture-taking and to get you out of trouble. But sooner or later you're going to find it limits your creativity, and you'll need to think about investing in a more powerful and more versatile gun.

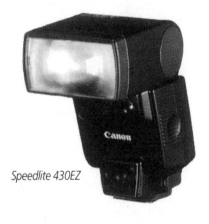

Speedlite 430EZ

The Canon Speedlite range offers a wide range of guns with varying power and features, but the one best suited for use with the Canon EOS5/A2/E is the excellent Canon

An example of bounced flash. The Canon
Speedlight 430EZ Flash was bounced off the
ceiling and so eliminated shadows on the back
wall. The white tablecloth and light coloured
"goodies" have reflected light back into the
children's faces.

Speedlite 430EZ. It has a zooming flash head, with a basic Guide Number of 43 (m/ISO100), which makes it about three times as powerful as the built-in gun, and is capable of covering a distance of about 13m with a 28-105mm zoom. Used with a lens with a faster maximum aperture, that distance will increase even further.

There's more to the 430EZ than sheer power though. This gun will also improve the quality of your picture-taking by opening up new photographic possibilities. The gun's bounce and swivel head, for instance, will allow you to bounce light off a wall or ceiling to give a much softer, more pleasing effect which is infinitely better than the in-your-face blast of a forward-facing head.

Like the small built-in gun, the Canon Speedlite 430 EZ interfaces electronically with the camera, via an A-TTL dedicated system, which, to give outstandingly accurate flash exposures, balances the flash light with ambient light to give natural-looking results.

Creativity is one of the 430 EZ's strong points. It offers "second-curtain" synchronisation, which improves the photography of moving subjects by timing the flash to fire at the end of the exposure, not the beginning. It also offers a Stroboscopic flash option, in which it fires a succession of flashes, up to 10 per second, to capture movement. You may have seen pictures of this type, often of golf swings or ballet, in photographic magazines such as Practical Photography or Photo Answers. The secret, as with Multiple-Exposures, is to use a black background, so that your flash-lit subject stands out sharply and clearly.

For heavy flash users, who start getting through a lot of batteries, a range of external battery packs is available separately.

USING THE PC SOCKET
X MARKS THE SPOT

A professional-specification camera should allow you to tackle any area of photography that takes your fancy. But not all do. Some lack important features, and one of the most important of all is a PC Socket, which you use to connect to external flash units. Why is it so important? Because if you're ambitious in your photography, and you almost certainly are since you bought a Canon EOS5/A2/E, then you'll inevitably want to spread your wings and have a go at everything.

So, as insignificant as it looks, that small PC Socket is actually a gateway into a huge new area of picture-taking.

USING A FLASHGUN OFF-CAMERA

Using a bigger, more powerful flash in place of the small, built-in gun is a positive step towards more professional picture-taking, but it has to be admitted that even if you bounce the light, the results, while they're better, are still not really that great.

To get any serious improvement you have to take the flashgun away from the camera completely, either mounting it to the side or higher – preferably both, using one of the excellent custom-made available flash brackets. That way you'll get a far more directional light which gives better modelling to pictures of people in particular.

One thing to remember is: you don't have to buy a Canon flashgun. You can, if you prefer, buy one of a large range of independent brands and connect it to the camera via the PC socket. You lose the dedication it's true, but if

you buy a computerised gun you should be able to get a similar level of exposure accuracy, but with greater versatility.

Adding a diffuser, or bounce accessory, such as one of those from the extensive Sto-Fen range, will increase your flashgun's versatility even more, by spreading the light to give a softer, more attractive ambience.

USING STUDIO FLASH

Once you've started taking pictures with the flashgun away from the camera you're well on the way to getting involved in one of the most exciting and challenging areas of photography: working in the studio. It's a small step from having a flash mounted on a bracket next to a camera to having one mounted on a stand in the studio – and the principles are exactly the same. They all plug into the PC Socket and fire when the camera's shutter is released.

Many people have a perception of studio photography as difficult: the province of professionals and no place for amateurs. Nothing could be further from the truth.

Of course there's a skill in using studio flash, but it's a skill that can be learned like any other. All you have to do is work with it for a while, and you'll soon understand how

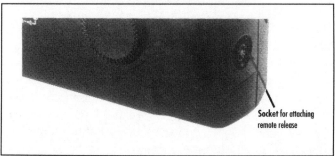

Socket for attaching remote release

to make the most of it.

And yes, studio lighting can be expensive, but you don't have to go out and buy everything all at once. One light plus a reflector is enough to start with. If that's outside your budget right now, you might think instead of hiring a studio: check out the ads in the back of photographic magazines to see if there's one near you.

TAKING MULTIPLE-EXPOSURES

If you've got a lively imagination, and have always fancied having a go at "trick photography", then this one's for you. The Multiple-Exposure function on the Canon EOS5/A2/E is your chance to get really creative by combining up to 9 different images on a single frame of film.

Think of all the things you could do! Include the same person twice, maybe having a fight with each other. Show a sequence of events, merge images, such as a glamour shot of a girl, and a sea, add a sun or moon to a landscape or night shot. The list, quite literally, is endless. The only limit is your imagination.

HOW TO SET THE CAMERA UP FOR MULTIPLE-EXPOSURES

To set the Multiple-Exposure function you press in the button at the bottom of the four on the camera back until you see overlapping rectangles and the number 1 appear on the top-plate LCD display. While continuing to hold the button in, you turn the Main Input Dial to the right – and you'll see the number change. This indicates the number of Multiple-Exposures, and goes up to a maximum of 9. When you've selected the number you want, release the

button on the back, and after a few seconds the display will return to normal – but with the double rectangles and number of multiple-exposures still showing.

As you start taking your series of multiple-exposures, the double rectangles start flashing as a warning, and the multiple-exposure counter in the top right-hand corner counts down, to tell you how many shots you've got left in this sequence.

When you've finished, press in the camera back button and turn the Main Input Dial to bring the counter back to 1.

Naturally, in the course of shooting, the main frame counter is de-coupled, so it only counts up the number of exposures used, not the number of multiple-exposures taken.

THE SECRETS OF SUCCESSFUL MULTIPLE-EXPOSURES

Thanks to modern technology, shooting multiple-exposures is now very easy to do. Unfortunately it still remains very easy to do badly. So here are one or two pointers to set you on the right road:

- If you've never done any multiple-exposure work before, shoot your first sequence in front of a black background, and make sure any objects or people don't overlap. This will do away with any need to mess around with exposure and will keep things technically very simple.
- Once you've got the hang of that, you can spread your wings a little and try something new. The important thing to remember is that as soon as parts of the scene start to overlap you'll need to adjust your exposure. So if, for instance, you merged two faces, one on top of the other, then you would need to halve the exposure for each – i.e. use the exposure

compensation if two pictures are to overlap. You need to underexpose each, typically by 1 stop.

- Remember you can change lenses in the middle of a sequence, so one possibility might be to shoot the same scene at up to nine different positions on a zoom lens.
- For the really serious, you don't have to be limited to nine multiple-exposures on a frame. When the counter gets down to one you can call up the M-E system and dial in 9 again. So in fact there's no limit to the number of shots you can put on one frame.
- Take advantage of Custom Function 8, which takes away the need to reset the Multiple-Exposure function every time. Useful if you're shooting a sequence of shots.

USING THE SELF-TIMER

The obvious and traditional use for the self-timer is to include yourself in the picture. You set the camera up, on a tripod or other support such as a convenient wall, frame a shot of family and friends, activate the self-timer, and then sprint around and join the group in the 10 seconds provided. And it's still as useful to be able to do that as it always was. There's nothing worse than looking through your holiday pictures only to find you're not in any of them. That's the trouble with being the photographer in the family, you can easily end up as the invisible man!

But there is another use you can put the self-timer to, which may not come as immediately to mind – and that's to help prevent camera-shake. Suppose you're out taking landscapes, and toward the end of the day, as the light levels begin to fall, you have before you the most exquisite scene you have ever witnessed in your life. You

have got to get this on film, but it's getting too dark to hand-hold, so you find a suitable support, and then you look in your bag only to find – darn it! – that you've left your remote release at home. What can you do, apart from tear your hair out? Simple: use the self-timer. Once it's set, and you've pressed the shutter release, the camera has 10 seconds to stop wobbling, and you should be assured of shake-free pictures.

An even better solution is to use Custom Function 12, which programs the camera so that when the shutter button is pressed completely in self-timer mode, the mirror flips up immediately, and the picture is taken 2 seconds later.

CUSTOM FUNCTIONS - PERSONALISING THE CAMERA TO MEET YOUR INDIVIDUAL NEEDS

As photographers, we are all individuals, with individual needs and preferences, a fact which many camera manufacturers seem to ignore. They expect photographers to adapt their way of working to suit the camera, not the other way round. Not so Canon, who seem to recognise their responsibility in making their camera fit as well as possible the needs of their users.

One of Canon's most important contributions to the world of camera design (and there have been many!) has been the introduction of Custom Functions. They're set at the factory, but designed to be over-ridden

Do you prefer to have the film leader wound back into the cassette – or left out? Would you like to have a mirror lock-up facility, to minimize camera vibration? How about having the autofocus start function operated by the AE-lock button, rather than the the shutter release?

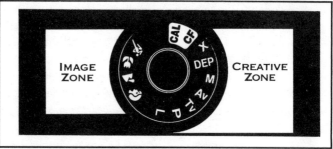

Well, with Custom Functions you can do all these things – and a whole lot more besides. The Canon EOS5/A2/E gives the user considerable control, with 16 Custom Functions, the highest number on any EOS camera to date, to fine-tune and personalise the camera to suit your own picture-taking style.

Now if all this sounds a bit complicated, and you're thinking that it's probably not worth the effort, think again! Canon have made what sounds a very complicated operation very simple in practise. In fact, once you know how to do it, setting or deleting a Custom Function can be done literally in seconds. The hard bit is remembering what each function stands for when you're out in the field!

SETTING A CUSTOM FUNCTION

To set a Custom Function you simply:

1. Turn the Command Dial to the "CF" position.

2. Rotate the Main Input Dial until the number of the function you want is displayed in the top-plate LCD panel, e.g. CO3.

3. Look for another number on the LCD panel. This will

be a 0 if the function is at its standard setting, or a 1 if the custom function has been set.

4. To switch the function on or off, simply press in once the Custom Function button (marked CF) on the camera back below the LCD panel.

N.B. Custom Functions have to be set and deleted individually. There is no "quick" way of erasing them all together.

THE 16 CUSTOM FUNCTIONS

CF1. Sets the automatic film wind to high-speed mode. The obvious advantage of this function is that it lets you remove and replace your film as quickly as possible. In standard rewind it takes about 20 seconds, depending on battery life, which can seem an interminable length of time when the most incredible picture-taking opportunity ever is right in front you. In such circumstances the CF2 high-speed rewind option of only 9 seconds is like water to a thirsty man. But there is another very real benefit. Because the film wind and rewind of the EOS5 is so incredibly quiet, it's perfectly possible to reach the end of a roll and not know it, only to discover suddenly that the film has been rewound. Not only is the CF1 function faster, it's also noisier (but not alarmingly so) which means you hear it start to rewind.

CF2. Leaves the film leader outside the cartridge after rewinding. One of the most important pieces of "housekeeping" for photographers is to know which films have been exposed and which have not. Sending an unexposed film to the processors is an annoying waste of 36 exposures. Putting a roll of film through the camera

twice and ruining two sets of pictures, is a nightmare no-one would ever want to live through. Which is why many photographers operate a simple system to avoid errors occurring: unexposed films have the leader out, exposed films have the leader in. And that's the basis that Canon have worked on when setting up the EOS5/A2/E – the leader gets wound in automatically when the film is rewound.

But with CF2 can you over-ride this and leave the leader out if you prefer to? Why might you want to? Perhaps you do your own processing, and find it easier if the leader's out. Or maybe you want to take out a part-used film, which you want to finish later. Clearly you'll need the leader out to reload it and finish it off.

CF3. Cancels automatic film speed setting with DX-coded film. Like most modern cameras, the Canon EOS5/A2/E sets the film speed automatically via the DX-coding system. A series of pins in the camera's film chamber read the black and silver chequerboard pattern on the film cannister and set the exposure system to the right ISO sensitivity. The DX-coding system has proved to be a great boon for photographers of all kinds. Not so long ago you had to remember to change film speed manually when switching from one film to another – and in the middle of a photo session it's easy to forget to do it. Result? Pictures that are either under- or over-exposed, and disappointment. Those days are gone now, and accurate exposure is virtually guaranteed.

The DX-coding system is great for most camera users, but some advanced photographers can find it limiting. You may have discovered through your own experience that certain films give their best at ratings different from those recommended by the manufacturer.

Slide films, for instance, often benefit from slight under-

exposure, and there are many photographers who generally rate Kodachrome 64 at ISO 80 or Fujichrome 100 at ISO125 for the biting saturation and rich colours achieved.

Print films, on the other hand, can produce muddy and flat results with even slight under-exposure, and there's a lot to be said for giving the merest hint of over exposure to ensure that colours and contrast stay strong. Try rating Kodak Gold 200 at ISO160 or even ISO125 and you should see a difference.

Users of black & white film, especially those who do their own developing and printing, often experiment with film speed, and this function lets them do just that.

Another reason to change film speed is that of up-rating your film – giving it a higher rating than the manufacturer suggests, effectively under-exposing it, and then increasing development to compensate. This technique of squeezing extra speed out of your film is much less common than it used to be, now that we have such a tremendous range of high-quality high-speed films to choose from. Nevertheless, it's still popular, and with the Canon EOS5/A2/E easy to do.

So much for the benefits of changing film speed. Now how to do it. The easiest way, if you just want to change the speed of one film, is to use the ISO button on the camera back (the one at the bottom). Simply press it in and turn the Main Input Dial until you see the film speed you want displayed on the top-plate LCD panel. Do be aware, though, that as soon as you put another film in, the camera will read the ISO rating from the film cannister and over-ride what was manually input.

If you regularly alter your film speeds, then take advantage of Custom Function 3, which requires that you manually input film speed yourself. The key thing to

remember is that, no matter what films you put into it, the film speed will remain the same until you change it.

CF4. Switches the autofocus start function from the shutter button to the AE-lock button. In normal use, the autofocus system of the Canon EOS5/A2/E is activated by half depressing the shutter release. This is a quick and very efficient system: once the lens has focused, you can continue the pressure, fully depress the shutter release, and go on to take the picture without delay. Some photographers, though, find that they occasionally press too hard when activating the autofocus system, and end up taking pictures accidentally. Custom Function 4 avoids that problem by using the AE-lock button on the camera back below the LCD panel to initiate autofocus, instead of the shutter release button. This does make picture-taking a sightly slower procedure, but has the benefit of minimising wasted frames. You might like to try both systems and see which you prefer.

CF5. Changes single exposure operation to allow the next exposure only after the shutter button has been fully returned to the "off" position. Dialling in Custom Function 5 ensures that there is a "fresh" meter reading every time you take a picture. It does this by requiring you to take the pressure off the shutter release between shots. In practise, exposure errors caused in this way are not a serious problem, but if you want peace of mind, then it's probably a useful precaution to set it.

CF6. Alters the function of the AE-lock button to temporarily stop autofocusing operation in A1 Servo AF Mode. This is a fairly specialist function, used when shooting sports or action subjects in A1 Servo AF. Choosing CF6 allows you to fix the focus at a certain point

by pressing the AE-lock button with your right thumb. This could be useful if, for instance, you want to pre-focus on a point through which the action will pass, and the subject is moving too fast for the predictive focusing to cope.

CF7. Stops the AF auxiliary light firing during autofocusing. When light levels are too low for automatic focusing, the EOS5/A2/E emits an AF auxiliary light which acts as a reference point for autofocus. Setting CF7 prevents the light from firing, although the advantages of doing so are not immediately obvious, since it may then be impossible to focus accurately. Claimed benefits are that the brightness of the light could irritate the subject in a portrait, and that cancellation could prevent the light from appearing in other people's pictures in situations where many people are taking pictures of the same scene.

CF8. Prevents cancellation of the the Multiple-exposure mode after a single frame. Shooting multiple-exposures can produce creative and fascinating results. Owners of the Canon EOS5/A2/E are fortunate indeed in having a camera which makes combining several exposures on one frame child's play. Simply access the multiple-exposure mode via the bottom button on the camera back, and you're ready to put up to 9 different images together. Trouble is, after each frame is completed, it goes back to normal picture-taking, and you have the hassle of calling up the multiple-exposure facility again and once again telling it how many shots you want to merge together. But opt for Custom Function 8 and you stay in multiple-exposure mode, and the camera even remembers how many pictures you want to combine!

CF9. Sets a shutter speed of 1/200 sec when using flash. When you're shooting indoors with flash in aperture-priority AE mode, the camera will almost certainly set a

slow shutter speed – and this can result in camera-shake. This very useful function prevents that happening, by fixing the shutter speed at 1/200 sec no matter how bright or dark it is.

CF10. Stops AF frames in the viewfinder from lighting. When a subject is focused, the AF frame, used for focusing, lights red in confirmation. And when you're using the camera with all five frames in operation, the red illumination also shows which one/s are being used to focus. If you find all these lights a bit distracting, then choosing CF10 will stop them lighting.

CF11. Adds Depth-of-field function to the AE-lock button. This is a very useful Custom Function. Simply by selecting CF11 you have, at your your thumb-tip, a convenient depth-of-field preview. All you have to do is focus, expose, and - while you hold those settings - press in the AE-lock button to get a visual idea of what will and won't be sharp in the finished picture. True, you can also get a depth-of-field preview by glancing up into the top left corner – but that only works when Eye-focus is switched on.

CF12. Mirror lock-up facility. Even on a camera as well engineered as the Canon EOS5/A2/E, vibration can occur when a picture is taken, which is why professionals and advanced amateurs in the know use a mirror lock-up facility whenever possible. To make your pictures as sharp as possible, select CF12, press in the top-plate self-timer button, fire the shutter – the mirror flips up immediately and the picture is taken two seconds later.

CF13. Cancels the metering timer function. In normal use, the illuminated green and yellow information panel at

the bottom of the viewfinder remains on for six seconds after your finger is removed from the shutter release. Setting Custom Function cancels this metering period, and conserves battery power by making the display cease when pressure on the shutter release ends.

CF14. Sets second-curtain flash synchronisation. In standard operation, flashguns synchronise with the first shutter curtain of the EOS5/A2/E. What happens is, that the first shutter blind opens completely, the flash fires, and then the second blind comes across. For static subjects this works very well, but can give a strange effect with moving subjects.

CF15. Links spot metering to the selected AF frame. If you like to use spot metering to ensure accurate exposure of your key subject, you need to be aware that, when set up normally, the camera's reading will still be taken from the centre of the viewfinder, even though the subject may be at one of the other AF focusing points. Dial in Custom Function 15, though, and that problem is solved – you can carry out spot metering at the same point as the selected AF frame, doing away with the need to change the scene composition during metering.

CF16. Cancels automatic flash reduction control. The Canon EOS5/A2/E features a very useful "automatic flash reduction system", which prevents underexposure in strongly backlit situations, such as afternoon sun. CF 16 switches it off.

Do take care not to ask the camera to set functions which are mutually incompatible – you can't have the AE-

lock button used for three different functions at the same time! So if both CF4 and CF6 are set, then only CF4 is used. Or if both CF4 and CF11 are set then only CF4 is used.

Custom Function warning! If your camera appears not to be functioning properly, check the status of your custom functions first. It's possible for custom functions to get changed accidentally, and if you're not prepared, some of them can seem like a malfunction.

MAXIMISING POWER - EXTENDING THE LIFE OF YOUR BATTERY

The Canon EOS5/A2/E, like most modern cameras, is totally dependent on battery power. Take out the battery, or let its power run down to nothing, and your state-of-the-art picture-taking machine is as dead as the proverbial Dodo.

And Sod's Law dictates that your battery will always die on you at the worst moment, such as in the middle of your daughter's wedding. So you need to make sure you're not caught out, and there are two sensible things you can do:

1. Pack a spare. The EOS5/A2/E uses a 2CR5 or equivalent, a 6-volt lithium battery. Compared to other types of battery, such as manganese and alkaline types, lithium batteries have a very good shelf-life – that is, they hold their charge for a long time unused – so it's worth having a spare should you need it unexpectedly.

Canon claim that a fresh 2CR5 lithium battery will power the EOS5/A2/E for up to 40 rolls if the flash isn't used, up to 20 rolls if flash is used half the time, and up to 12 rolls if flash is used all the time.

That's a useful guide on how long you can expect the battery to last, but there are so many other factors involved (see below) that you can never be sure. Taking a look at the top-plate LCD panel battery check indicator on a regular basis is also worthwhile – you'll see then when the battery's getting to the stage of needing to be replaced.

2. 2CR5 batteries are expensive, so it's worth getting as much use out of them as possible – and that means using the camera wisely and carefully. Because the camera is electronic, there are many things which the battery is called upon to do – some obvious, some less so. Here they are:

POWER ALL THE MOTORS

• film wind and rewind
• focus the lens
• stop down the lens aperture

Battery Life (Number of film rolls)

Temperature	Flash not used	50% flash use	100% flash use
Normal (+20°C/68°F)	40 rolls	20 rolls	12 rolls
Low (-20°C/-4°F)	15 rolls	9 rolls	—

• Data based on Canon's Standard Test Method (Using a new battery and 24 exposure film; Lens: EF 28~105mm f/3.5-4.5 USM; Shutter speed: 1/1000 sec; Lens focus driven from infinity to closest shooting distance and back, then shutter button held at halfway position for six seconds before each frame;

POWER THE BUILT-IN FLASHGUN
AND AUXILIARY FOCUSING LIGHTS

POWER THE INFORMATION PANELS

- top-plate LCD
- viewfinder LCD and AF Frames

FIRE THE ELECTRONIC SHUTTER

Some of these you have little or no control over, except in respect of how many pictures you take. Others you can affect. Overall, you should avoid:

- Focusing unnecessarily. This can put a very big drain on the battery, especially if you use long lenses that need powerful motors to focus them.

- Using the built-in flashgun unnecessarily. As we saw above, excessive use can eat up batteries. It may work out more economical in the long run to buy a separate, accessory flashgun which uses cheaper, alkaline, AA-type batteries.

Other things you can do to conserve power are:

- Use custom function 13 to program all displays to switch off the moment pressure is taken off the shutter release.

- Switch the Command Dial to L whenever the camera is not in use, disconnecting the battery from the camera's electronics.

CANON EOS5/A2/E QD
DATA-BACK MODEL

There is also a data-back version of the Canon EOS5/A2/E, called the QD (quartz date), sold in some markets, which will automatically imprint, in orange, a range of date information directly onto the bottom right of the negative/print or slide.

The back incorporates a built-in automatic calendar programmed with dates up to the year 2019, and the date and time can be imprinted in one of four different formats – or, if preferred, switched off.

The options are: (pressing the Mode button changes the format in the following sequence):

1. Year/Month/Day.
2. Day/Hour/Minute.
3. No Imprint.
4. Month/Day/Year.
5. Day/Month/Year.

It's also possible to change the date and time when travelling to a different time-zone. Here's how:

1) Press the Mode button to display the date/time on the LCD panel.
2) Press Select so that the first setting position be changed begins to blink, then press Set to input the number you want.
3) Repeat Step 2 until everything is set. When you've finished, press Select again, until all positions stop flashing.

REMINDER!: The data-back is powered by a 3-volt CR2025 battery with a life of around 3 years. When the

LCD panel becomes hard to read you'll need to change it. The battery is positioned inside the camera back, clearly visible, under a cover which you'll need to loosen to get access.

LENSES FOR THE EOS5/A2/E - ENTER A WORLD OF OPTICAL OPPORTUNITY!

One of the reasons that many people choose to buy a Single-Lens Reflex camera such as the Canon EOS5/A2/E is the enormous wealth of picture-taking opportunities opened up by being able to fit a range of different lenses.

Not long ago SLRs were supplied with a 50mm "standard lens", that sees the world very much as we do, regardless of whether you wanted one or not. But things have changed, and many cameras are offered with a "standard zoom", and it's likely that with your EOS5/A2/E came "standard zoom" of some kind, probably the EF 28-105mm zoom specifically designed with the camera in mind.

Such a lens is tremendously versatile, offering wide-angle through to telephoto photography in one compact package, and capable of tackling a wide range of photographic assignments. The 28mm wide-angle end is suitable for landscapes, groups of people, architecture and interiors. The 105mm short telephoto end is ideal for individual portraits, close-ups, pets, and some kinds of action. The focal lengths in the middle can be used for all kinds of general picture-taking.

A lens such as the EF 28-105mm will take you some time before you start to exhaust its possibilities, but

sooner or later you'll start thinking about buying another lens to widen your picture-taking horizons, and you'll find yourself hanging around in photo stores and turning the pages of photo magazines longingly.

The first thing you have to decide is whether you want to go longer or wider – the decision depends, of course, on what sort of pictures you like taking.

If you're into wildlife, sport and candids, then you need something longer, probably one from the excellent range of Canon EF telezooms.

If, on the other hand, your leaning is toward photographing big buildings or creating dramatic perspective in landscape, then you need to consider one of the range of Canon EF Ultra-wide-angles lenses.

Eventually, of course, you'll want to build up a complete system, a bagful of lenses that will allow you to cover every eventuality.

WHY CHOOSE CANON EF LENSES?

As well as Canon lenses, there are a variety of other lenses on the market, many of them at very attractive prices compared to those made by Canon. Why should you buy Canon? Well, there are a lot of good reasons:

- Canon's lenses are renowned for their sharpness, contrast and colour quality – and at the end of the day it's the quality of the results you get back from the lab that's the most important thing. Canon is the leader in the use of aspherical glass elements, fluorite crystal and Ultra-Low Dispersion (UD) glass, and their lenses are optically second to none.
- As the Canon EOS5/A2/E itself shows, Canon are at the cutting edge of technology, and that is as true for

their lenses as it is for the cameras themselves. From the beginning every EF lens has contained its own custom-designed autofocus motor and electromagnetic diaphragm, providing fast and accurate focusing and exposure. But with the introduction of Ultrasonic Motors (USM) into the lenses, Canon have moved even further ahead of the game. Fit a Canon EF Ultrasonic Lens to your camera, such as the EF 28-105mm zoom, and you'll be amazed at 1) how quickly it focuses, and 2) how quietly it focuses. Canon have declared that their dream is to produce lenses which are as quick and as quiet as the human eye. On the basis of the EF USM lenses currently available, they're very close to achieving that dream.

- A strong advantage of buying Canon-made lenses is that you're guaranteeing compatibility not only with the current system, but also with what is to come in the future. Who knows what models Canon may introduce this year, next year or the year after. But you can be certain they will try to ensure that the lenses currently available work on future models.

- Another factor worth considering is that Canon lenses are styled cosmetically to match and look good with each other and with camera Canon bodies – that's not also true of independent lenses.

- Although they're designed primarily for autofocusing, Canon's lenses can all still be focused very effectively by hand, and are provided with sufficiently wide, serrated focusing rings to that end.

- And finally, Canon now have a huge number of lenses in their EF range, over 40, with something to meet every

photographic need you have now or are likely to have in the future. Let's take a look at some:

EF LENSES FOR THE CANON EOS5/A2/E

ULTRA-WIDE-ANGLE EF LENSES

If you're looking for dramatic pictures, look no further than the two ultra-wide-angle EF lenses from Canon. Their eye-popping perspective produces pictures that certainly get people talking. Even the most mundane scene takes on a magical shape with one of these on your camera.

Try the EF14mm f/2.8L USM for photographs that seem

to go from here to infinity, with depth-of-field like you've never seen before.

Or have a go with the the Fish-eye EF 15mm f/2.8. It's a full-frame fish-eye with an incredible 180 degree angle-of-view. See it swallow up the world, and watch in amazement as straight lines go bendy and distortion takes over.
Take care you don't get your feet or fingers in the picture!

WIDE-ANGLE EF LENSES

Whatever your wide-angle need there's a lens to meet it in the Canon EF range. One of the latest to be added is the EF 20mm f/2.8 USM. This superb lens takes in a sweeping perspective and is ideal for landscapes and architectural shots with impact. Keep the camera straight and you get natural, square perspective. Tilt the camera back and you'll see converging verticals make all the lines

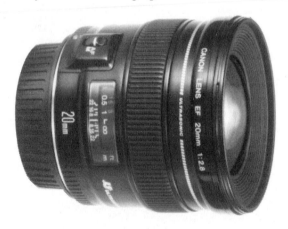

go diving diagonally in, towards some distant vanishing point.

The EF 24mm f/2.8 and the EF 28mm f/2.8 offer a more "normal" wide-angle perspective – that is they take in a lot more than a standard 50mm lens, but without the distortion you get from wider focal lengths.

Very few people buy 35mm wide-angle lenses these days, perhaps because they seem very tame compared to what else is on offer. Even so, it's good to see that Canon have the EF 35mm f/2 in their range for those who want one.

If you're a wide-angle kind of person through-and-through, why not take a look at the incredible EF 20-35mm f/2.8L. It covers all the popular wide-angle focal lengths in one compact lens, has a fast maximum aperture of f/2.8, and incredibly sharp. Call it wide-angle heaven! It's not cheap, but then the best never is.

STANDARD LENSES

In many ways it's a shame to see standard lenses falling from favour in the face of the rise in popularity of the standard zoom, because they have so much going for them: a fast maximum aperture that makes low-light shooting possible, close minimum focus, and incredible sharpness. The EF 50mm f/1.8 MkII is a great standard, and with a weight of only 130grams you hardly know you've got it on the camera. Not so the outrageously-fast EF 50mm f/1.0L USM, the fastest standard lens ever made for an SLR, which weighs over seven times as much. If you need speed, this is it.

STANDARD ZOOMS

As we mentioned earlier, the new EF 28-105mm 3.5-4.5 USM, with which many EOS5/A2/E cameras will be sold,

is a first-class general-purpose lens, and one of a number of Canon EF standard zooms on offer. If you own or have owned a Canon EOS 1000/Rebel, you may have used one of the EF 35-80mm f/4-5.6 USM and EF 35-105mm f/4.5-5.6 USM lenses sold with that camera. If you'd like more coverage at the telephoto end of the scale, choose instead the EF 35-135mm f/4-5.6 USM.

For some people, though, 35mm won't be wide enough at the bottom end, and they'll opt for a lens that goes down to 28mm. The first choice here is the EF 28-80mm f/3.5-5.6, a neat, attractive lens at a sensible price. At the top-end of the standard zoom scale is the professional EF 28-80mm f/2.8-4L USM, designed for optimum optical performance, particularly in the suppression of flare.

TELEPHOTO LENSES

Sales of fixed focal length telephoto lenses have been steadily declining with the increase in popularity of telephoto zooms. But they still have a great deal to offer the discerning photographer: principally sharpness and speed.

Lenses in the range 85 to 100mm are widely know as portrait lenses, because of the flattering perspective they give to pictures of people. Canon have three lenses in this range: the EF 100mm f/2 USM, the EF 85mm f/1.8 USM, and the EF 85mm f/1.2L USM. All focus down to around 3 feet, and their fast maximum apertures are very useful for throwing backgrounds out of focus and concentrating attention on the subject.

Sadly, the 135mm focal length seems to have gone the way of the 35mm – few people are interested in it these days. But the Canon EF 135mm f/2.8 has something else to offer beyond its focal length – a continuously-variable

soft-focus option that's ideal for creating a romantic mood, instantly.

If it's a little more pulling power that you're after, then consider the EF 200mm f/2.8L USM and EF 200mm f/1.8L USM. Both will give you a bright, clear viewfinder image and good sharpness, but the 1.8L version, built with professionals in mind, weights 3000grams and is 200mm long.

As you go beyond the 200mm, you get into long- or super-telephoto lenses. These are rarely used for general picture-taking – anyone buying one usually has a specific interest in mind. This could be photographing birds, other wildlife, sport – they're even used by fashion photographers on the catwalk. There are five super-telephoto EF lenses: the EF 300MM F/4L USM, EF 300MM F/2.8L USM, EF 400mm f/2.8L USM, EF 500mm f/4.5L USM and EF 600mm f/4L USM. All are hellishly heavy – book your weight-lifting sessions now!

TELEPHOTO ZOOMS

Most people buy their EOS camera these days with a standard supplied, so the first additional lens they look to buy is often a telephoto zoom – often now called a telezoom. And in the Canon EF range they've got plenty of choice.

One of the most affordable telezooms on offer is the EF 80-200mm f/4.5-5.6 USM., but that doesn't mean any corners have been cut. You get the same commitment to sharpness that you do in a more expensive optic. The difference lies in the maximum aperture, which is not as fast as the pro-specification EF 80-200mm f/2.8L.

If you want a bigger range than the 2-and-a-half times ratio of the 80-200mms, then the EF 70-210mm f/3.5-4.5 USM could be your cup of tea.

If you want a stronger telephoto effect, but still prefer a zoom, you might like to investigate the three Canon EF zooms that go up to 300mm. One of the most popular is the EF 100-300m f/4.5-5.6 USM, a fast-focusing lens that's tremendously sharp. If the faster maximum aperture isn't important to you, then go for the more attractively-priced EF 100-300mm f/5.6L. For those who want to cover all telephoto bases, the EF 75-300mm f/4-5.6 USM is the ultimate Canon telezoom.

MACRO LENSES

If playing with the Close-up Automatic mode on the Canon EOS5/A2/E has caught your imagination, then you might think of buying one of Canon's special macro lenses. There are two: the EF 50mm f/2.5 Compact Macro doubles as a standard lens but gives magnification up to half-life-size — full life-size when used with the Life Size Converter EF. Using a 50mm macro can put you a bit close to your subject, and if you prefer more working room give the EF 100mm f/2.8 Macro a try. Without accessories it gives 1:1 life-size reproduction, and also makes a perfect portrait lens.

TILT-SHIFT LENSES

If you ever need to take pictures where the perspective is just right, perhaps of buildings where everything must be square, the you need the three specialist Tilt-Shift lenses

in the Canon range: a 24mm f/3.5L, 45mm f/2.8 and 90mm f/2.8 are available.

EXTENDERS

Extenders, or teleconverters as their sometimes known, are simple accessories that fit between the lens and the camera body., and offer a relatively inexpensive way of increasing the versatility of your current lenses range.

Canon make two extenders: EF 2x extender which doubles the focal length any lens you use it with, and EF 1.4x, which increases focal length by 40%. Both are intended for use with any fixed focal length lens from 200mm to 600mm.

ACCESSORIES USEFUL ADD–ONS

CANON VG10 VERTICAL GRIP

This is not so much an accessory as a necessity – if you take many pictures with the camera turned on its side. The VG10 Vertical Grip fits neatly onto the camera base – you just have to remove one small cover with a coin – to produce a camera that handles every bit as well vertically as it does horizontally. The grip cleverly replicates all the controls that are usually accessed by the right hand – i.e. the shutter release, AE-Lock button, Main Input Dial, AF Focusing Point Selector. An optional hand strap is also available.

CANON 60T3 REMOTE SWITCH

Everyone knows that it's essential to use a tripod when you have a long exposure time, otherwise your picture will be ruined by camera-shake. But not everyone realises the benefit of securing the camera solidly at normal, hand-holding shutter speeds, especially when using telephoto lenses. Even the slightest movement at the moment of exposure can take the edge of sharpness away.

However, supporting the camera so it doesn't move isn't enough on its own. You have to make sure you don't cause any vibration when you release the shutter – which means you can't press down on the shutter release in the normal way.

One option is to take advantage of Custom Function 12, with gives you a 2-second delay on the self-timer, with the mirror locking up.

But a better alternative is to buy a Canon 60T3 Remote Shutter Release, which plugs into the 3-pin remote control socket on the side of the camera and allows you to fire the shutter, quickly and easily, by pressing the Remote Switch rather than the camera's shutter release.

CANON REMOTE LEAD 1000T3

If you need to put some space between you and the camera when firing the shutter, perhaps for bird or wildlife photography, you need to get the Canon Remote Lead 1000T3, which gives you 10m working distance.

INTERCHANGEABLE FOCUSING SCREENS

The Canon EOS5/A2/E comes supplied with a Standard Matte focusing screen, which is ideal for general shooting

with all lenses.

But if you have specialist needs, you can buy, and fit yourself, one of a range of alternative focusing screens. Each comes complete with a special tool, and installation is a simple and straightforward job. But do take the greatest of care when handling Focusing Screens – they have a high-precision finish, and scratch very easily indeed.

OPTIONAL SCREENS:

- Screen with Focusing Marks: also used for general photography with a wide range of lenses, but with the addition of marks corresponding to the shape of the focusing sensors.

- Matte Screen with Grid: this screen's squared-off grid makes it ideal for architectural photography, copying work, or any kind of picture taking where straight lines are very important.

- Matte Screen with Scale: having a scale engraved at the centre and edges of this screen makes it ideal for close-up shooting, enlarging and micro-photography.

- All Matte Screen: can also be used for general shooting with all lenses.

OP/TECH STRAP

Although the Canon EOS5/A2/E is by no means heavy, you might find, that when fitted with a telezoom lens, such as the excellent 100-300mm f/4-5.6 USM, it can get tiring after a while – if you use a normal strap. However, if you fit one of the elasticated, cushioning straps made by

Op/Tech – available from all good camera stores – you'll be able to tote the camera around all day without a care in the world.

CANON EOS5/A2/E
SPECIFICATIONS AT-A-GLANCE

Type: 35mm focal-plane shutter Single-Lens Reflex (SLR) camera with autofocus, auto-exposure, built-in flash and built-in motor-drive.

Lens mount: Canon EF mount (electronic signal transfer system).

Viewfinder: Fixed eye-level pentaprism showing 92% vertical and 94% horizontal of actual picture area with 0.73x magnification with 50mm lens at infinity.

LCD Panel: Displays information including frame counter, AF Mode, film winding mode, metering mode, shutter speed, aperture value, film speed, battery condition, and exposure compensation.

Dioptric adjustment: Built-in eyepiece is adjusted to -1 diopter.

Focusing Screen: Interchangeable, overall matte screen with AF Frames supplied.

Shutter: 1/8000sec – 30 seconds and bulb.

Maximum X-sync speed: 1/200 sec.

AUTOFOCUS

AF Control System: TTL-SIR (Secondary Image Registration) phase - detection type using Cross-type BASIS (BAse-Stored Image Sensor).

Autofocus Modes Available: One-shot AF and AI Servo. Manual Focusing also possible.

Focusing Point: Five focusing points provided. Focusing point set automatically by camera, manually, by user or by user eye-control.

AF Working Range: EV0 – 18 at ISO 100.

AF Auxiliary Light: Projects automatically when necessary. Operation linked to focusing points.

EXPOSURE CONTROL

Light Metering: TTL (Through-The-Lens) full-aperture metering using a 16-zone SPC (silicon photocell). Three metering modes available: evaluative metering, spot metering (approx 3.5% of central picture area), and centre-weighted average metering.

Metering Range: EV0 – 20 with 50mm f/1.4 lens at ISO 100.

Shooting Modes: Program AE; Shutter-priority AE; Aperture-Priority AE; Depth-of-Field AE; Full Auto; Programmed Image Control (Portrait, Landscape, Close-

up, Sports); Flash AE; X, flash sync mode; Manual Exposure.

Multiple-Exposures: Up to nine can be pre-set
Exposure Compensation: +/−2 stops in 1/2stop increments.

Auto-Exposure-Bracketing: +/-2 stops in 1/2 stop increments.

FILM TRANSPORT

Film Speed Setting: Automatically set according to DX Code (ISO 25-5000) or set by user (ISO 6-6400).

Film Loading: Film automatically advances to first frame when back cover is closed.

Film Wind: Automatic using dedicated miniature motor. Three speeds available: single exposure, 3 frames-per-second, and 5 frames-per-second.

Film Rewind: Automatic rewind at end of roll.

OTHER

Self-Timer: Electronically controlled with 10-second delay.

Custom Function Control: Sixteen built-in Custom Functions selectable by the user.

POWER SOURCE

Battery: One six-volt lithium 2CR5 type.

SIZE:

Dimensions: 154mm (w) x 120.5mm (h) x 74.2mm (d).
Weight: 665g (body only, no battery)

BUILT-IN FLASH

Type: Retractable-type TTL automatic zoom flash housed in pentaprism.

Guide Number: (ISO 100) 13 (28mm) to 17 (80mm).

Flash Coverage Angle: Automatically zooms to cover the field of view of 28mm, 50mm, and 80mm focal lengths.

Recycling Time: Approximately 2 seconds

Firing Conditions: Fires automatically in low light or backlit conditions in Full Auto and some Programmed Image Control Modes.

X-Synch Speed: Automatically set to 1/60 sec – 1/200 sec in program modes according to TTL flash AE program. Automatically set to 30 – 1/200 sec in aperture-priority mode according to ambient light conditions. Manually set to 1/200 sec or slower in shutter-priority AE and manual exposure modes. Manually set to 1/60 sec, 1/90 sec, 1/125 sec, or 1/200 sec in X mode.

DATE FUNCTION:

QD Model Only:

Type: Built-in Date/time imprinting function using dot LED with automatic calendar programmed with dates to 2019.

Date Imprint Formats:

1. Year/Month/Day.
2. Day/Hour/Minute.
3. No Imprint.
4. Month/Day/Year.
5. Day/Month/Year.

Imprint Colour: Orange

Clock Precision: Variation of +/– 90 seconds or less per month.

Power Source: One dedicated 3v lithium CR2025. Approx life: 3 years.

<Year Month Day>
↓ '92 10 15 (October 15, 1992)
<Day Hour Minute>
↓ 15 16 45 (4:45 pm on the 15th)
<Hyphen display>
↓ - - - - - - (No imprint)
<Month Day Year>
↓ 10 15'92 (October 15, 1992)
<Day Month Year>
 15 10'92 (October 15, 1992)

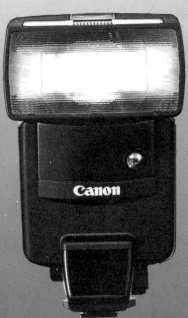

ACCESSORIES WELL WORTH LOOKING AT!

OP/TECH

The world's most comfortable cameras, bag and tripod straps (binoculars too). Op/tech has a built-in weight reduction system that makes equipment feel 50% lighter and 100% more comfortable. From the famous 'Pro-Camera Strap' to the 'Bag Strap' and the 'Tripod Strap', the style, colours and comfort which along with the non-slip grip, ensure that you have a wonderful combination of comfort and safety.

BAG STRAP

The **OP/TECH USA Bag Strap** is the answer to the problem of carrying a heavy bag for extended periods of time. By combining the patented weight reduction system with the Non Slip Grip™, you have the perfect strap for camera/video bags and cases as well as garment bags. Adjustable from 29" to 52", this strap is one of a kind. You will feel the difference!

STO-FEN

The ultimate lightweight diffuser system for high powered modern flashguns. Sto-Fen offers the 'Omni-Bounce' for overall soft diffusion – often called the "softie" – which weighs in at just 15 grams and the 'Two-Way' Bounce Card for those who prefer to direct diffused light from their flash. The 'Two-Way' only weighs 25 grams, so it adds almost nothing to the overall weight of the flash. Sto-Fen are the lightest weight, most effective flash diffuser products on the market today.

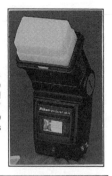

PELI-PELICAN CASES

Watertight and airtight to 30 feet for the ultimate in protection. Constructed of light weight space age structural resin with a neoprene "O" ring seal and exclusive purge valve. Supplied complete with pre-scored pick n'pluck foam or padded dividers. Also includes locking flanges, massive multiple latches for absolute security and best of all, a comfortable molded grip handle.

JERSEY PHOTOGRAPHIC MUSEUM

OVER 1000 CAMERAS AND PHOTOGRAPHIC
ACCESSORIES ON SHOW FROM 1850 TO THE PRESENT DAY

EXHIBITION OF PHOTOGRAPHS IN THE GALLERY
CONSTANTLY CHANGING

**OPEN 0900 - 1700 HOURS MONDAY-FRIDAY
CLOSED PUBLIC HOLIDAYS
ADMISSION CHARGE - £1**

THE PHOTOGRAPHIC MUSEUM IS LOCATED IN THE CHANNEL
ISLANDS BETWEEN ENGLAND AND FRANCE IN THE LARGE
**HOTEL DE FRANCE, CONFERENCE & LEISURE COMPLEX
ST. SAVIOUR'S ROAD, ST. HELIER,
JERSEY, C.I. JE2 7LA
TEL. (01534) 614700 FAX (01534) 887342**

AMPHOTO
BOOKS FOR PHOTOGRAPHERS

50 Portrait Lighting Techniques
for Pictures That Sell
REVISED EDITION

The Field Guide to
Photographing Flowers

Understanding Exposure
HOW TO SHOOT GREAT PHOTOGRAPHS

The Field Guide to
Photographing Landscapes

JUST A FEW TITLES FROM THE EXTENSIVE LIST
OF "WORKSHOP" BOOKS FROM THE WORLD'S
BIGGEST AND BEST PUBLISHER OF HIGH
QUALITY, BUT AFFORDABLE PHOTO BOOKS